T0275345

THE ——————— LAST

PLACE THEY

THOUGHT OF

1

FOREWORD

AMY SADAO

Each year the contributions of our Whitney-Lauder Curatorial Fellow extend ICA's curatorial vision. Daniella Rose King's voice has been one of the clearest and most prescient. *The Last Place They Thought Of* visualized black women's geographies in profoundly moving ways. I am grateful to Daniella for this deeply felt, powerfully researched, and beautifully conceived project.

We are truly grateful to the artists Torkwase Dyson, Jade Montserrat, Lorraine O'Grady, and Keisha Scarville, and to Charlie Davidson, Alia Fattouh, Carly Fischer, Alejandro Jassan, Derek Rigby, and Alexander Gray Associates for their help presenting the artists' works.

I thank Treva Ellison for their contribution to the catalog and new thinking on "Vantapower" presented as a lecture at ICA. We are honored to reprint excerpts of Katherine McKittrick's *Demonic Grounds: Black Women and the Cartographies of Struggle*. Professor McKittrick's work guides the exhibition, lends its title, and continues to inspire.

Once again, I thank ICA's devoted and talented installation team of Emilia Brintnall, Aaron Carrol, Emily B. Elliott, Isaac Lin, Preston Link, Adam Lovitz, Patrick Maguire, Julia Policastro, Jay Roselius, Lydia Smith, and Sophie White as led by Chief Preparator Paul Swenbeck.

Book designer Paige Hanserd, photographer Constance Mensch, and our programming team of Alex Klein and Tausif Noor also have my gratitude for making the publication and public events possible.

And finally, I am grateful for the continued support from Vice Provost for Faculty Anita L. Allen, Provost Wendell Pritchett, and President Amy Gutmann, and from ICA's Board President Stephen R. Weber and the entire Board of Overseers.

ACKNOWLEDGEMENTS

DANIELLA ROSE KING

This exhibition was germinated in the pyscho-geography of the black Atlantic; located somewhere between London, Barbados, the Lake District, Brooklyn, Newburgh, Maine, and Philadelphia. Looking back, I began to see, in Ingrid Pollard's words, "the rural in the city, the city within the rural." *The Last Place They Thought Of* is indebted to and inspired by Pollard's *Pastoral Interlude* (1987), a series of photographs and text that has played on my mind for many years and was massively generative in my curatorial and theoretical approach to this exhibition.

Likewise, it is heavily indebted to the work and words of Katherine McKittrick, whose theorizing of black geographies and mapping of black women's movements, locations, and displacements throughout the black diaspora was foundational to this exhibition. I am deeply thankful to Katherine for bringing this scholarship to the world. She also generously let me borrow the exhibition title from her book *Demonic Grounds: Black Women and the Cartographies of Struggle,* along with some key excerpts that punctuate this publication and lend it so much weight, rigor, and poetry. I thank Adam Elliott-Cooper for introducing me to Katherine and encouraging my nascent preoccupation with black geographies.

So much of this exhibition is owed to conversations between others, and none more so than the artists included. Thank you to Lorraine O'Grady; an artist of immeasurable significance and intellectual grit, it was always a dream of mine to show her work, and I am grateful that she not only allowed this, but also lent her voice to early discussions of the exhibition, its shape, and its concerns. I thank Jade Montserrat for her energy and willingness to debate rural belongings and becomings in the run-up to the exhibition and far beyond. I

am very grateful to count her as a thinking and writing partner. I am also hugely indebted to Keisha Scarville for being such a pleasure to work with, for so generously speaking about her work for a program at ICA; and for her continued friendship. And lastly I thank Torkwase Dyson for her commitment to black compositional thought; it was an honor to include her work in the exhibition.

To Treva Ellison, I express sincere gratitude for their incredible lecture and essay for this book, "Vantapower." I am truly honored to have this piece of writing included in *The Last Place They Thought Of*. Ellison carefully balances insightful readings of the exhibition as a whole and the artworks as microcosms with the social and theoretical underpinnings of black geographies. Their essay demonstrates how much is at stake when we think of place, space, and power in the wake of black feminist epistemologies.

Many thanks are due to my colleagues at the ICA. To Amy Sadao, thank you for sharing in my enthusiasm for the artists and work in *The Last Place They Thought Of*, and for championing my

work. To Anthony Elms for making space and providing support and curatorial rigor. His guidance allowed me to feel out and experiment with ideas in the process of curating the exhibition. Thanks to Lauren Downing for essential administrative support, carried out with utmost care and attention to detail. Special thanks also to Meg Onli and Caitlin Palmer for their endless support bringing this book to fruition, as well as for thoughtful discussions around the exhibition. I am especially grateful to Alex Klein for her sage advice around the programming of the exhibition. And to all of the curators, including Kate Kraczon, thank you all for welcoming me aboard and providing such generative feedback and criticism throughout the process of curating this exhibition.

I will be forever grateful to Paul Swenbeck, Robert Chaney, Mandy Bartram, Kate Abercrombie, and the rest of the crew who bent over backwards to make organizing and installing the exhibition, as well as returning the work to its owners, a truly positive experience for all involved. For seamless organizational and technical support and delivery of my two programs, sincerest thanks

to Derek "Delboy" Rigby and Tausif Noor. I am incredibly grateful to Constance Mensch for so considerately documenting the exhibition.

Thank you to the talented Paige Hanserd for her thoughtful design of this publication. From start to finish it has been a pleasure to think and work with her, and I am incredibly indebted to her enduring patience. Much gratitude to Other Means (Gary Fogelson, Phil Lubliner, and Ryan Waller) for a delightful set of interpretative and promotional materials. And thank you also to Jill Katz for kindly supporting the production and dissemination of these.

For constant, unconditional friendship, guidance, and intellectual rigor I am heavily indebted to the following individuals: (stateside) Sam Kingfisher, Julia Phillips, Simone Leigh, Trista Mallory, Naeem Mohaiemen, Patrice Renee Washington, and Oliver Lee Terry; (and across the pond) Yansé Cooper, Aimée Allam, Amanprit Sandhu, Nomaduma Masilela, Linda King, and Simone Trimmingham. I'm honored to count you as friends, and I see your love and support here on every page.

GEOGRAPHIES OF DOMINATION, TRANSATLANTIC SLAVERY, DIASPORA

KATHERINE MCKITTRICK

Black matters are spatial matters. And while we all produce, know, and negotiate space—albeit on different terms—geographies in the diaspora are accentuated by racist paradigms of the past and their ongoing hierarchical patterns. I have turned to geography and black geographic subjects not to provide a corrective story, nor to "find" and "discover" lost geographies. Rather, I want to suggest that space and place give black lives meaning in a world that has, for the most part, incorrectly deemed black populations and their attendant geographies as "ungeographic" and/ or philosophically undeveloped. That black lives are necessarily geographic, but also struggle with discourses that erase and despatialize their sense

of place, is where I begin to conceptualize geography. I therefore follow the insights of Kathleen Kirby, noting that the language and concreteness of geography—with its overlapping physical, metaphorical, theoretical, and experiential contours—must be conceptualized as always bringing into view material referents, external, three-dimensional spaces, and the actions taking place in space, as they overlap with subjectivities, imaginations, and stories.[4] I want to suggest that we take the language *and* the physicality of geography seriously, that is, as an "*imbrication* of material and metaphorical space,"[5] so that black lives and black histories can be conceptualized and talked about in new ways. And part of the work involved in thinking about black geographies is to recognize that the overlaps between materiality and language are long-standing in the diaspora, and that the legacy of racial displacement, or erasure, is in contradistinction to and therefore evidence of, an ongoing critique of both geography and the "ungeographic." Consequently, if there is a push to forge a conceptual connection between material or concrete spaces, language, and subjectivity, openings are made possible for envisioning an interpretive alterable world, rather than a transparent and knowable world.

[4] Kathleen Kirby, *Indifferent Boundaries: Spatial Concepts of Human Subjectivity*, 9.
[5] Neil Smith and Cindi Katz, "Grounding Metaphor: Towards a Spatialized Politics," in Michael Keith and Steve Pile, eds., *Place and the Politics of Identity*, 80. My emphasis.

Geography, then, materially and discursively extends to cover three-dimensional spaces and places, the physical landscape and infrastructures, geographic imaginations, the practice of mapping, exploring, and seeing, and social relations in and across space. Geography is also Geography, an academic discipline and a set of theoretical concerns developed by human geographers, such as the importance of the ways in which material spaces and places underpin shifting and uneven (racial, sexual, economic) social relations. In order to examine black women's relationship to these diverse geographic conceptualizations, I have employed the term "traditional geography," which points to formulations that assume we can view, assess, and ethically organize the world from a stable (white, patriarchal, Euro-centric, heterosexual, classed) vantage point. While these formulations—cartographic, positivist, imperialist—have been retained and resisted within and beyond the discipline of human geography, they also clarify that black women are negotiating a geographic landscape that is upheld by a legacy of exploitation, exploration, and conquest.[6] If we imagine that traditional geographies are upheld by their three-

[6] See: Gillian Rose, "Progress in Geography and Gender. Or Something Else?" 531–37; Derek Gregory, *Geographical Imaginations*, 5–9. It is important to note, then, that "traditional geography" and "traditional geographies," throughout the study, refer to both the discipline of human geography and dominant geographic patterns.

dimensionality, as well as a corresponding language of insides and outsides, borders and belongings, and inclusions and exclusions, we can expose domination as a visible spatial project that organizes, names, and sees social differences (such as black femininity) and determines *where* social order happens.

The history of black subjects in the diaspora is a geographic story that is, at least in part, a story of material and conceptual placements and displacements, segregations and integrations, margins and centers, and migrations and settlements. These spatial binaries, while certainly not complete or fully accurate, also underscore the classificatory *where* of race. Practices and locations of racial domination (for example, slave ships, racial-sexual violences) and practices of resistance (for example, ship coups, escape routes, imaginary and real respatializations) also importantly locate what Saidiya Hartman calls "a striking contradiction," wherein objectification is coupled with black humanity/personhood.[7] In terms of geography, this contradiction maps the ties and tensions between material and ideological dominations and oppositional

[7] Saidiya Hartman, *Scenes of Subjection: Terror, Slavery, and Self-Making in Nineteenth Century America*, 5.

spatial practices. Black geographies and black women's geographies, then, signal alternative patterns that work alongside and across traditional geographies.

Indeed, black matters are spatial matters. The displacement of difference, geographic domination, transatlantic slavery, and the black Atlantic Ocean differently contribute to mapping out the real and imaginative geographies of black women; they are understood here as social processes that *make* geography a racial-sexual terrain. Hence, black women's lives and experiences become especially visible through these concepts and moments because they clarify that blackness is integral to the production of space.[8] To put it another way, social practices create landscapes and contribute to how we organize, build, and imagine our surroundings. Black subjects are not indifferent to these practices and landscapes; rather, they are connected to them due to crude racial-sexual hierarchies *and* due to their (often unacknowledged) status as geographic beings who have a stake in the production of space. Black women's histories, lives, and spaces must be understood

[8] The production of space refers to: any landscape that arises out of social practices; the historical production of spatiality through racialized, gendered, and classed forms of geographic organization. Derek Gregory, *Geographical Imaginations*, 356; Neil Smith, *Uneven Development: Nature, Capital and the Production of Space*, 78. And a note on "blackness": throughout the study, I borrow from Rinaldo Walcott, *Black Like Who?* xiv–xv.

as enmeshing with traditional geographic arrangements in order to identify a different way of knowing and writing the social world and to expand how the production of space is achieved across terrains of domination.

The production of space is caught up in, but does not guarantee, longstanding geographic frameworks that materially and philosophically arrange the planet according to a seemingly stable white, heterosexual, classed vantage point. If prevailing geographic distributions and interactions are racially, sexually and economically hierarchical, these hierarchies are naturalized by repetitively spatializing "difference." That is, "*plac[ing]* the world within an ideological order," unevenly.[9] Practices of domination, sustained by a unitary vantage point, naturalize both identity and place, repetitively spatializing where nondominant groups "naturally" belong. This is, for the most part, accomplished through economic, ideological, social, and political processes that see and position the racial-sexual body within what seem like predetermined, or appropriate, places and assume that this arrangement is commonsensical. This naturalization of

cont'd: Walcott writes that blackness is most usefully understood as "a sign, one which carries with it particular histories of resistance and domination ... questions of blackness far exceed the categories of the biological and ethnic . . . [it is] a discourse, but that discourse is embedded in a history or a set of histories which are messy and contested."

[9] Audrey Kobayashi and Linda Peake, "Unnatural Discourse: 'Race' and Gender in Geography," 227. Emphasis in the original.

"difference" is, in part, bolstered by the ideological weight of transparent space, the idea that space "just is," and the illusion that the external world is readily knowable and not in need of evaluation, and that what we see is true. If *who* we see is tied up with *where* we see through truthful, commonsensical narratives, then the placement of subaltern bodies deceptively hardens spatial binaries, in turn suggesting that some bodies belong, some bodies do not belong, and some bodies are out of place. For black women, then, geographic domination is worked out through reading and managing their specific racial-sexual bodies. This management effectively, but not completely, displaces black geographic knowledge by assuming that black femininity is altogether knowable, unknowing, and expendable: she is seemingly in place by being out of place.

The simultaneous naturalization of bodies and places must be disclosed, and therefore called into question, if we want to think about alternative spatial practices and more humanly workable geographies. Borrowing from Ruth Wilson Gilmore, I want to suggest

that geographies of domination be understood as "the displacement of difference," wherein "particular kinds of bodies, one by one, are materially (if not always visibly) configured by racism into a hierarchy of human and inhuman persons that in sum form the category of 'human being.'"[10] Gilmore highlights the ways in which human and spatial differentiations are connected to the process of making place. The displacement of difference does not *describe* human hierarchies but rather demonstrates the ways in which these hierarchies are critical categories of social and spatial struggle. Thus, practices of domination are necessarily caught up in a different way of knowing and writing the social world, which foregrounds the "geographical imperatives," that lie "at the heart of every struggle for social justice."[11] This material spatialization of "difference"— for my purposes, the spatialization of the racial-sexual black subject—in various times and locations in turn makes visible new, or unacknowledged, strategies of social struggle. Geographic domination, then, is conceptually and materially bound up with racial-sexual displacement and the knowledge-power of a unitary vantage point. It is not a finished or

[10] Ruth Wilson Gilmore, "Fatal Couplings of Power and Difference: Notes on Racism and Geography," 16.
[11] Ibid., 16.

immovable act, but it does signal unjust spatial practices; it is not a natural system, but rather a working system that manages the social world. It is meant to recognize the hierarchies of human and inhuman persons and reveal how this social categorization is also a contested geographic project.

I draw on the history of transatlantic slavery to illustrate that black women are both shaped by, and challenge, traditional geographic arrangements. My discussions are underwritten by transatlantic slavery because this history heightens the meanings of traditional arrangements, which rest on a crucial geographic paradigm, human captivity. Transatlantic slavery profited from black enslavement by exacting material and philosophical black subordinations. A vast project, the practice of slavery differently impacted upon black diaspora populations in Africa, the Caribbean, South America, Canada, the United States, and various parts of Europe, between the seventeenth and nineteenth centuries. Slavery differed markedly in different locations. For example, periods of institution and abolishment, the scale of

the trade, and uses of slave labor all produce unique time-space differentiations. At the same time, the particularity of slaves' lives and selves—gender, age, labor tasks, phenotype, ethnicity, language, time, place—fracture the meanings of slavery even further. As histories, recollections, and narratives of slavery clearly demonstrate, different slaves negotiated bondage in very different ways.[12] While it is not within the scope of this introduction or project to particularize and spatialize all geographies of transatlantic slavery, I sketch out below the central ideas that have shaped my analysis.

What I feel is important to outline in terms of the geographies of transatlantic slavery and my larger discussion on black women's geographies is not so much the vast and differential processes of captivity. Instead, I turn to slavery, through memories, writings, theories, and geographies, to address the idea that locations of captivity initiate a different sense of place through which black women can manipulate the categories and sites that constrain them. Of course the technologies and violences of slavery, as they are spatialized,

[12] For example, compare the slave narratives in Henry Louis Gates Jr., *The Classic Slave Narratives*, Olaudah Equiano, Mary Prince, Frederick Douglass, Harriet Jacobs/ Linda Brent, whose narratives span 1789–1861, are gendered, and are authored by one African, two African Americans, and one Caribbean. For recollections, see also B. A. Botkin, ed., *Lay My Burden Down: A Folk History of Slavery*; Ira Berlin, Marc Favreau, and Steven F. Miller, eds., *Remembering Slavery*.

do not disappear when black women assert their sense of place. But black women also *inhabited* what Jenny Sharpe calls "the crevices of power" necessary to enslavement, and from this location some were able to manipulate and recast the meanings of slavery's geographic terrain.[13] Their different practices of spatial manipulation make possible a way to analyze four interrelated processes that identify the social production of space: the naturalization of identity and place, discussed above; the ways in which geographic enslavement is developed through the constructs of black womanhood and femininity; the spatial practices black women employ across and beyond domination; and the ways in which geography, although seemingly static, is an alterable terrain.

I have drawn on the legacy of transatlantic slavery to advance a discussion of black women's geographic options as they are, often crudely, aligned with historically present racial-sexual categorizations. More specifically, transatlantic slavery incited meaningful geographic processes that were interconnected with the category of "black

cont'd from page 21: Finally, see David Barry Gasper and Darlene Clarke Hine, eds., *More Than Chattel: Black Women and Slavery in the Americas,* for essays examining gender and slavery in different historical and geographic contexts.
[15] Jenny Sharpe, *Ghosts of Slavery: A Literary Archaeology of Black Women's Lives,* xxi.

woman": this category not only visually and socially represented a particular kind of gendered servitude, it was embedded in the landscape. Geographically, the category of "black woman" evidenced human/inhuman and masculine/feminine racial organization. The classification of black femininity was therefore also a process of *placing* her within the broader system of servitude—as an inhuman racial-sexual worker, as an objectified body, as a site through which sex, violence, and reproduction can be imagined and enacted, and as a captive human. Her classificatory racial-sexual body, then, determined her whereabouts in relation to her humanity.

As some black feminists have suggested, the category of "black woman" during transatlantic slavery affects—but does not necessarily twin—our contemporary understandings of human normalcy.[14] Further, our present landscape is both haunted *and* developed by old and new hierarchies of humanness. If past human categorization was spatialized, in ships and on plantations, in homes, communities, nations, islands, and regions, it also evidences the ways in which

[14] For example see: Hortense J. Spillers, "Mama's Baby, Papa's Maybe: An American Grammar Book," 454–81; Marlene Nourbese Philip, "Dis Place—The Space Between," *A Genealogy of Resistance and Other Essays*, 74–112; Patricia Hill Collins, *Black Feminist Thought*.

some of the impressions of transatlantic slavery leak into the future, in essence recycling the displacement of difference. Of course, much has changed in the natural and social environment, but our historical geographies, and the ways in which we make and know space now, are connected; they are held together by what Carole Boyce Davies and Monica Jardine describe as "a series of remapping exercises in which various land spaces are located within an orbit of control."[15] I am not suggesting that the violence of transatlantic slavery is an ongoing, unchanging, unopposed practice, but rather that it is a legacy that carries with it—for black and nonblack peoples—"living effects, seething and lingering, of what *seems* over and done with."[16]

I want to suggest that the category of black woman is intimately connected with past and present spatial organization and that black femininity and black women's humanness are bound up in an ongoing geographic struggle. While black womanhood is not static and ahistoric, the continuities, contexts, and ruptures that contribute to the construction of black femininity shed light on how black

[15] Carole Boyce Davies and Monica Jardine, "Imperial Geographies and Caribbean Nationalism: At the Border between 'A Dying Colonialism' and U.S. Hegemony," 162.
[16] Avery Gordon, Ghostly Matters: *Haunting and the Sociological Imagination*, 195.

women have situated themselves in a world that profits from their specific displacments of difference. Identifying black women as viable contributors to an ongoing geographic struggle, rather than, for example, solely through the constructs of "race" or race/class/gender/sexuality is critical to my argument: I want to emphasize that contextual spatial analyses do not relegate black women to the margins or insist that the spatialization of black femininity "just was" and "just is." While I have suggested that geography—through and beyond practices of domination—is an alterable terrain through which black women can assert their sense of place, questions of "race," or race/class/gender/sexuality, are contributors to the where of blackness, rather than the sole indicators of identity/experience.

So, what philosophical work can geography actually do for us, as readers and occupiers of space and place, if it is recognizably alterable? What is at stake in the legacy of exploration, conquest, and stable vantage points if we insist that past and present geographies are connective sites of struggle, which have *always* called into question the very *appearance* of

safely secure and unwavering locations? And what do black women's geographies make possible if they are not conceptualized as simply subordinate, or buried, or lost, but rather are indicative of an unresolved story?

I am emphasizing here that racism and sexism are not simply bodily or identity based; racism and sexism are also spatial acts and illustrate black women's geographic experiences and knowledges as they are made possible through domination. Thus, black women's geographies push up against the seemingly natural spaces and places of subjugation, disclosing, sometimes radically, how geography is socially produced and therefore an available site through which various forms of blackness can be understood and asserted. I do not seek to devalue the ongoing unjustness of racism and sexism by privileging geography; rather I want to stress that if practices of subjugation are also spatial acts, then the ways in which black women think, write, and negotiate their surroundings are intermingled with place-based critiques, or, respatializations. I suggest, then, that one way to contend with unjust and uneven human/inhuman categorizations

is to think about, and perhaps employ, the alternative geographic formulations that subaltern communities advance. Geographies of domination, from transatlantic slavery and beyond, hold in them both the marking and the contestation of old and new social hierarchies. If these hierarchies are spatial expressions of racism and sexism, the interrogations and remappings provided by black diaspora populations can incite new, or different, and perhaps more just, geographic stories. That is, the sites/citations of struggle indicate that traditional geographies, and their attendant hierarchical categories of humanness, cannot do the emancipatory work some subjects demand. And part of this work, in our historical present, is linked up with recognizing both "the where" of alterity *and* the geographical imperatives in the struggle for social justice.

Spatial acts can take on many forms and can be identified through expressions, resistances, and naturalizations. Importantly, these acts take place and have a place. One of the underlying geographic themes and "places" in this work is the black diaspora and the black Atlantic. Discussions draw on the work, ideas,

and experiences advanced by theorists, writers, and poets from Canada, the United States, the United Kingdom, and the Caribbean. I have not drawn on these diasporic locations to reify a monolithic "black space," but rather to examine how practices of and resistances to racial domination across different borders bring into focus black women's complex relationship with geography. I cite/site several diasporic texts in order to consider where geopolitical strategies take place in the face of racial dominations. This conceptual framing of black diaspora geographies is in part inspired by Paul Gilroy's *The Black Atlantic: Modernity and Double Consciousness.*

Gilroy's *The Black Atlantic* has allowed me to think about black populations as part, but not completely, of geography. The text focuses on alternative geographies, countercultural positions, which are simultaneously deemed ungeographic yet hold in them long-standing spatial negotiations. And this positionality—in Canada, the United States, the United Kingdom, the Caribbean—is inextricably linked to a discourse of modernity wherein questions of progress are underwritten by the terrors of

slavery, the living memories of slavery, and diasporic migrations. Further, the idea of "belonging" in and to place—whether it be a particular nation, a specific community, real/imagined Africa, homelands—is incomplete, premised on a struggle toward some kind of sociospatial liberation. Importantly, this struggle can go several ways at once: it might be developed through the language of nation-purity, or desired reconciled belongings that reiterate hetero-patriarchal norms; it might be formulated as Pan-Africanism, or through "outernational" musical exchanges and cultural borrowings; it might draw on European thought, Afrocentric philosophies, or both; it might foresee black nations, in Liberia, Ethiopia; it might involve crossing borders or enforced, chosen, temporary, or permanent, exiles. Black Atlantic populations, then, inhabit place in a unique way, which is, in part, upheld by geographic yearnings and movements that demonstrate "various struggles toward emancipation, autonomy, and citizenship" and a reexamination of "the problems of nationality, location, identity and historical memory."[17] *The Black Atlantic* works to loosen the naturalization of (black)

[17] Paul Gilroy, *The Black Atlantic: Modernity and Double Consciousness*, 16.

identities and place, arguing for the ways in which a different sense of place, and different geographic landmarks, might fit into our historically present spatial organization. And while his critique of transparent space is not explicit, Gilroy does provide some tools through which we might reconsider the terms of place, belonging, and unfulfilled liberties. That is, he sites black geographies through a terrain of struggle.

What I continue to like about Gilroy's text is the way he develops these ideas alongside geographic materialities. His work is not often examined for his invocation of three-dimensionalities, which correspond with how we can understand the space of the black subject.[18] Of course, *The Black Atlantic* is not a forthright spatial investigation; indeed, criticism includes Joan Dayan's discussion of what she describes as Gilroy's slave ship and middle passage metaphors, symbols which, she argues, produce a deterritorialized "cartography of celebratory journeys."[19] But I want to read *The Black Atlantic*, and the black Atlantic, differently: as an "imbrication of material and metaphorical space,"[20] in part because

[18] Exceptions include some of the essays collected in the special "Black Atlantic" issue of Research in African Literatures.

[19] Joan Dayan, "Paul Gilroy's Slaves, Ships, and Routes: The Middle Passage as Metaphor," 7–14.

[20] Neil Smith and Cindi Katz, "Grounding Metaphor: Towards a Spatialized Politics," in Michael Keith and Steve Pile, eds., *Place and the Politics of Identity*, 80.

the text is so noticeably underscored by a very important black geography, the Atlantic Ocean, through which the production of space can be imagined on diasporic terms. In fact, I would suggest that it is precisely because Gilroy draws on real, imagined, historical, and contemporary *geographies*, that Dayan can imagine and document the materialities, the landscapes, he elides in this work. That is, metaphors of the middle passage or the Atlantic Ocean are never simply symbolic renditions of placelessness and vanishing histories—this is too easy and, in my view, reinforces the idea that black scholars and writers are ungeographic, trapped in metaphors that seemingly have no physical resonance. Coupling Gilroy's insights into modernity and intellectual histories with his decision to position black cultures in relation to the Atlantic Ocean and other physical geographies helps to explicate where the terrain of political struggle fits into black cultural lives. I suggest that if *The Black Atlantic* is also read through the material sites that hold together and anchor the text—the middle passage, the Atlantic Ocean, black travelers in Europe, Canada, and elsewhere, the slave ship, the plantation,

shared outernational musics, fictional and au-tobiographical geographies, nationalisms— it clarifies that there are genealogical connec-tions between dispossession, transparent space, and black subjectivities. Historical and contemporary black geographies surface and centralize the notion that black diaspora pop-ulations have told and are telling how their surroundings have shaped their lives. These connections flag, for example, the middle pas-sage, expressive cultures, and the plantation on historio-experiential terms, spatializing black histories and lives, which are underwritten by the displacement of difference. It is important, then, to recognize that black Atlantic cultures have always had an intimate relationship with geography, which arises out of diasporic pop-ulations existing "partly inside and not always against the grand narrative of Enlightenment and its organizing principles"[21]; principles that include the naturalization of identity and place, the spatialization of racial hierarchies, the displacement of difference, ghettos, prisons, crossed borders, and sites of resistance and community.

[21] Paul Gilroy, *The Black Atlantic*, 48.

THE LAST PLACE
THEY THOUGHT OF

MAPPING SOME
VISUAL PARADIGMS
OF BLACK FEMINIST
GEOGRAPHIES

DANIELLA ROSE KING

The opinion was often expressed that I was in the Free States. Very rarely did any one suggest that I might be in the vicinity. Had the least suspicion rested on my grandmother's house, it would have been burned to the ground. But it was the last place they thought of. Yet there was no place, where slavery existed, that could have afforded me so good a place of concealment.[1]

Geographically, in the most crude sense, the body is territorialized—it is publicly and financially claimed, owned, and controlled by an outsider. Territorialization marks and names the scale of the body, turning ideas that justify bondage into corporeal evidence of racial difference.[2]

The ungeographic is the last place they thought of; it is the spatial register of flesh and underscores that blackness is positioned in an indeterminate relationship to the production of space and time as knowable and calculable tools and systems of power.[3]

[1] Harriet Jacobs, *Incidents in the Life of a Slave Girl: Written by Herself*, ed. Jennifer Fleischner (Boston: Bedford/St. Martin's, 2010), 137.
[2] Katherine McKittrick, *Demonic Grounds: Black Women and the Cartographies of Struggle* (Minneapolis: University of Minnesota Press, 2006), 45.
[3] Treva Ellison, "Vantapower," this volume.

The Last Place They Thought Of was an exhibition of four distinct projects that together mapped a convergence of knowledges, histories, and aesthetic paradigms for disentangling the body from space and place. It also marked the beginning of a new chapter of personal curatorial inquiry and research that seeks to highlight and aggregate the contributions of visual artists in dialogue with black feminisms and geography. Within this context, geography is understood as encompassing the land and its respective ecologies, historic (and historically determined / contingent) processes of mapping and territorialization, as well as a set of subjective, social, and ideological structures. These paradigms govern, shape, and dictate the way that humans move, speak, engage one another, and imagine themselves in public and private space, and they are constantly being revised and re-created. By engaging critically with geography through the lens of black female subjectivities and feminisms, *The Last Place They Thought Of* examined the historical and contextual specificities of black women's locations and displacements throughout the black diaspora. The exhibition reconsidered how geography pertains to the environment and our changing climate; how it regulates the production and performance of identities, and how it continues to uphold material and metaphorical borders and boundaries.

We are living in the wake of forced and voluntary movements and migrations, made centuries ago, and continue to feel the legacies of chattel slavery along the well-trafficked routes of the transatlantic slave trade.[4] Mirroring this era of human exploitation, heralded by colonizing white supremacist patriarchs, is the ecocide set in motion by plantation economies, racial capitalism, and the subsequent industrialization of global landscapes. As such, it would seem to be of utmost urgency to identify the architects of the Anthropocene and those of nascent capitalism as one and the same. The original, primitive accumulation of capital made possible by chattel slavery financed the scaffolding of capitalism and continues to circulate in the market. Processes of racism, colonialism, and endless extraction coalesce within and undergird the institutions of transatlantic slavery and thus global capitalism. Time has served only to ossify these processes of inequality and exploitation within society's social organization, and the planet's physical landscapes are marked by

[4] For more on this theory of the wake and the afterlives of slavery, see Christina Sharpe, particularly chapter one "The Wake," in *In the Wake: On Blackness and Being* (Durham, NC and London: Duke University Press, 2016), 1-24.

even more destructive, yet contingent industries. These include the prison-industrial complex and its carceral geographies; the spatial configurations of environmental racism; acres of soil-depleting monocrops laden with pesticide; polluted oceans, lakes, and rivers; receding glaciers and ice caps; land filled with waste or mined to the point of collapse; estranged relationships to "nature" and rural spaces; food deserts; sprawling, overpopulated cities set on concrete, prone to floods and overheating; and widespread poverty and structural inequality. Each work in *The Last Place They Thought Of* focuses on a subset of these problems and, with a concern for specificity and a depth of engagement, speaks to the universal, intersecting, and conditional character of their symptoms.

I borrowed the exhibition title from a chapter in Katherine McKittrick's seminal 2006 book *Demonic Grounds: Black Women and the Cartographies of Struggle*. This text acted as a theoretical and historical framework through which to explore readings of blackness, diaspora, and geography—specifically, how "black women's historical-contextual locations bring to bear on our present geographic organization."[5] *The Last Place They Thought Of* presented an intergenerational group of artists who in various ways take up, expand upon, and diverge from McKittrick's conception of black women's geographies. At the same time, the exhibition posited that the artists not only reflect on our present organization, but also suggest and imagine more equitable, capacious spatial futures. Black female subject positionality allows us to examine how gender, race, and class intersect to constitute specific types of exploitation, violence, and erasure. By examining geography as a historically afflicted process shaped by colonialism, capitalism, white supremacy, and patriarchy, I sought ruminations on and considerations of ecology, history, space, and landscape through the lens of black women's experiences. The artists in this exhibition interrogated the geographic implications of particular histories on specific spaces. From the intimate cartographies of a body to the imagined and constructed contours of the black Atlantic; from the ecology of the North York Moors to the ruins of slave auction blocks, plantation fields, lynching trees, and Underground Railroad routes in North America, to a magical realist vision of a river-bound voyage in Guyana.

[5] McKittrick, *Demonic Grounds*, xxvi.

The interrogation of these overlapping and interconnected black geographies provided generative and expansive alternative narratives of space, place, and history that challenge racist histories of erasure, alienation, and displacement.

Literal and rhetorical marginalization, *being in the last place*, is arguably "an experiential geography [...] of black gendered bodies."[6] In Lorraine O'Grady's video *Landscape (Western Hemisphere)*, 2010–2011, questions of place—specifically the "ungeographic" (after all, where is "black"?)—miscegenation, and hybridity arise through the contours of a black female body depicted as a landscape. These cartographies sit alongside those of the water table, transatlantic slave trade, and Underground Railroad in the paintings of Torkwase Dyson. Fabulation and magical realist narratives of the land emerge through a study of imagined topographies in Keisha Scarville's *The Placelessness of Echoes (and kinship of shadows)*, 2016–2018. Literary histories of the landscape and their moorings in the black Atlantic comingle with corporeal materials in Jade Montserrat's performative and ephemeral wall drawing, *Untitled (The Wretched of the Earth, After Frantz Fanon)*, 2018. Language and the written word, historical testimony, and a concern for the ground, the land, the earthly underpinnings of our geographic condition, reveal themselves in different, critical ways throughout *The Last Place They Thought Of*.

McKittrick herself borrowed "the last place they thought of" from Harriet Jacobs (who published under the alias Linda Brent), a writer who escaped slavery by hiding in her grandmother's garret—a space measuring nine by seven by three feet, tucked away above the kitchen—for seven years, in close proximity to the slave master who never stopped trying to recapture her. Henry "Box" Brown, who escaped from slavery by mailing himself in a box, is another historical and literary figure whose remarkable maneuvering of space, and malleability of his own person, is registered in the exhibition. Philadelphia, where this exhibition was staged, has a close and notorious relationship to the history of slavery in the Americas. Slave labor was integral to the region even before the first slave ship docked on the city's shores in 1684. Only a few miles from the present-day ICA stood the London Coffee House (opened in 1754), an auction house where enslaved men, women, and children

[6] McKittrick, *Demonic Grounds*, 55.

were sold. Despite this, in 1780 Pennsylvania was the first state to pass an abolition act, described as a gradual emancipation law. It also hosted a large and prominent community of abolitionists and their sympathizers, and by the nineteenth century had one of the largest and most influential free black communities in the United States. Philadelphia had vigilance committees who would protect the black community from slave catchers and harbor and abet escaped slaves on the Underground Railroad. Jacobs first tentatively tasted freedom in Philadelphia after sailing from North Carolina in 1842. Seven years later, Brown squeezed into a 36 x 32 x 24 inch box dispatched to his co-conspirator, an abolitionist in Philadelphia. For Jacobs and Brown—and countless others—Philadelphia was a geography tied to their journeys of enfranchisement. The garret and the box, for Jacobs and Brown respectively, operated as architectures of confinement and liberation, captivity and concealment. It is these paradoxical potentials of geography and space—and the attendant possibilities offered by being *in the last place they thought of*—that concerned this exhibition.

HOW BODILY
GEOGRAPHY CAN BE.[7]

Lorraine O'Grady's video *Landscape (Western Hemisphere)*, 2010–2011, running 18 minutes in length, comprises a series of close-ups of the artist's hair being agitated subtly by an off-screen breeze. The tight framing of these long takes serves to abstract the image, so that it appears as an undulating field of underbrush, grasses, or other fertile landscape as seen from above, and possibly at a great distance. These images are paired with audio recorded in a variety of rural and urban landscapes across the Western Hemisphere—including the rumble of traffic, planes flying overhead, birdsong, crickets, and cicadas—a cinematic partnership that might trick viewers into believing they are watching an episode of *Planet Earth* or a documentary on the National Geographic Channel. Analogous to the experience of watching a cinematically scaled nature documentary, *Landscape (Western Hemisphere)* has the effect of mesmerizing the viewer, engendering a disassociation from the image. A few seconds at the end of the film disrupt the illusion, as we are shown a fleeting silhouette of the artist's full head. This clue to the nature of the materials we have been watching brings us

[7] McKittrick, *Demonic Grounds*, 44.

back to our bodies, and to a scale that is familiar and relative. This work, a lynchpin of the exhibition, was the first to be included in my curatorial thesis, in large part for how it very simply uses abstraction to conflate the body with the landscape. O'Grady suggests that simultaneous processes—racialization and gendering—have historically been enacted on both the body and the land to justify their respective exploitation, extraction, and debasement

These processes she locates at the beginning of the colonial period, upon the so-called discovery of the Americas and the project to homogenize and control the Western Hemisphere (essentially anywhere west of the prime meridian that passes through Greenwich, London, and east of the antemeridian located in the open waters of the Pacific Ocean). In the English-speaking world, the term "Western Hemisphere" is used interchangeably with "the West" and "the Americas." Its meaning is anchored in the arrogant, hubristic desires of an empire to insist that the Royal Borough of London is the center of the world—or at least a geographically significant threshold between East and West, old and new. The history of the Western Hemisphere is one of exchange, hybridity, and miscegenation; of theft, exploitation, and terror. Principles of white supremacy, patriarchy, and capitalist ambition created a terrible hegemony that sanctioned centuries of exploitation, domination, and violence perpetrated and performed upon people and place. These forces are responsible for the Anthropocene, and for structural inequality, racism, and sexism. The afterlives of slavery and their paradoxical spatial configurations are embodied by the image of O'Grady's hair, an overburdened signifier of ethnicity, race, and difference. For the artist, mixed-race hair is a metaphor for the miscegenation of the Western Hemisphere, is its objective correlative, and her practice is ostensibly concerned with the history of hybridization specific to the Americas. In *Landscape (Western Hemisphere)* O'Grady creates an irrefutable account of the historic, intersecting schemas of geography, race, and gender.

Throughout her oeuvre, O'Grady has approached the body as a site of experience and shared history. In *Landscape (Western Hemisphere)* she transforms her hair into a capacious, fecund ground as a relocation and re-centering of the black female body and its subjec-

tivities. The work also conjures the hiding places, cover, refuge, and camouflage the natural habitat has provided to besieged individuals on their emancipatory journeys. Like Harriet Jacobs and others before and after her, the landscape held the capacity for captivity and bondage, but also escape and renewal. Likewise, the landscape, as approached by O'Grady's lens, holds the capacity for geographic belonging and possibility, when other narratives of place and space—of diverse and hybrid ethnic and sexual identities—can emerge and displace the master narratives of history.

UNTITLED
(THE WRETCHED OF THE EARTH,
AFTER FRANTZ FANON), 2018

My dear friend, I know that you, and you alone,
possess peace
Freedom will blossom from the skies of
prisms**prisons

Magnificent terrifying waterfall flowing like
celebration
Dig with elbows where the veridical light touched

Her dyeing garden measured the value of peace
Whose transformation has in fact set the whole
process in motion

A contagion of boldness; I made you with love
Perpetual renewal felt as a triumph for life

Spoken with her whole body she consists of the
recording that comes from the volcanos
Her body sounds like the silence of that place**pace

Braiding her need in absolute rest within an
earthbound altar of joy
Disappearance into appearance; A deep and
unremarked possession

The certainty of love and healing, redemption and
comfort, the aged twine that binds us
The routine surprise of colour; Our names do not
appear

Her body, alone, concealed, an act of rebellion
Brought into sharper relief: her body, valued, repaired,
something he cannot understand, has arrived

It took three full days for Montserrat to complete the site-specific wall drawing *Untitled (The Wretched of the Earth, After Frantz Fanon)*, 2018. The work wholly consumed ICA's ramp space, filling the wall from floor to ceiling. The installation found equal inspiration in practices of protest, public murals, performance, literary traditions and testimony, and drawing. Montserrat borrowed language from a heterogeneous range of sources, cutting and excerpting, interweaving with her own prose and poetry. The references create a diasporic reader, a transatlantic literary landscape that addresses the multiplicitous legacies of racism, sexism, and colonialism and how these converge with the land. The authors she excerpted included bell hooks, Toni Morrison, Dionne Brand, anonymous Philadelphia graffiti artists, Josephine Baker, Frantz Fanon, Donna J. Haraway, Adrienne Rich, Aristophanes, and Katherine McKittrick.

Montserrat spent her formative years in a rural setting in the north of England, surrounded by rolling fields, peat bogs, and clay pits. The charcoal used for the installation is made by hand on this same landscape, forming a strong, direct connection to the earth and to the artist's home. Charcoal is a bounteous and generous material, which allows us to think through the planet's changing climate and our physical, material relationship to others. From the earliest cave drawings, charcoal has been used for millennia to record information and make art. It also creates a tangible link between Jacobs's written testimony of 1861 and Montserrat's speculative poetry of 2018. The creation of the work was a performance that Montserrat undertook in the nude, becoming covered in charcoal dust in the process. This performance was grueling, and the toil it took on her body required days of recovery at its completion. Positioning herself within the artwork, she bridged the words "Her body, alone, concealed, an act of rebellion" to that of Jacobs's experience of hiding in the garret. Further, Montserrat's naked, laboring body became a radical gesture, a reinsertion of the black female body into a literary and historical geography.

[8] Jade Montserrat, *Untitled (The Wretched of the Earth, After Frantz Fanon)*, 2018. Site specific charcoal wall-drawing, dimensions variable. Courtesy of the artist.

Weaving a thread between the abolition and prison abolition movements, Montserrat locates the transatlantic slave trade in the prison industrial complex when she writes, "Freedom will blossom from the skies of prisms**prisons,"—graffiti observed on her train journey from Philadelphia airport to ICA in April 2018. Montserrat's dialogical, dynamic use of language serves to fracture meanings, create etymological connections, expand definitions, and blur space. As calls to action or interlocutors, their slippages offer apertures that resist the colonial underpinnings of the English language: dying becomes dyeing; peace is changed to piece, and place to pace; prisons are transformed to prisms. Deconstructing and reimagining language is a decolonial practice. Haraway advises that, as descendants of imperial histories engaged in the "conjugat[ing] of new worlds," we must resist the homogenizing and flattening nature of universals and instead bring about partial and unfixed semantic connections.[9]

As the work was completed, Montserrat and I nicknamed the piece "contagion" (it was too late to change the title in our printed materials) as a nod to the line "A contagion of boldness; I made you with love" and for the contaminating effect of the charcoal in the space. I watched as visitors' curiosity overcame them and, despite the warnings, they touched and smudged the drawing. Montserrat was particularly excited at the thought that this organic material, carbon—a building block of all organic matter in the universe, ourselves included—could defy property and reach beyond the confines of the gallery walls. As a contagion, it could covertly hitch a ride on the bodies of unknowing visitors, or as a fugitive, stow away inside their respiratory systems, intermingling on a cellular level, conjoining body, land, and word in a triumphant communion.

THE IMPOSSIBLE START HAPPEN I TELL YOU. WATER START DREAM, ROCK AND STONE START DREAM, TREE TRUNK AND TREE ROOT DREAMING, BIRD AND BEAST DREAMING . . .[10]

The speculative potential of the land emerges through Keisha Scarville's photographic installation *The Placelessness of Echoes (and kinship of shadows)*, 2016–2018. A visual essay of sorts, this sprawling series of photographs is inspired, in large part, by Guy-

[9] Donna Haraway, *Staying with the Trouble: Making Kin in the Chthulucene* (Durham, NC: Duke University Press, 2016), 13.
[10] Wilson Harris, *Palace of the Peacock* (London: Faber and Faber, 2010), 87.

anese author Wilson Harris's book *Palace of the Peacock* (1960). Harris's richly metaphorical first novel is a nonlinear post-colonial fiction that describes an ethnically diverse crew aboard a ship,ship, and their unscrupulous pursuit of cheap indigenous labor in the jungles of Guyana. The crew encounters the shapeshifting Mariella, who appears both as a young woman and as a territory within the narrative. The journey takes on a spiritual significance, and explores themes of transformation, belonging, and sanctuary. This is all imbued with the contemporaneous back-drop of international independence movements, reckonings with national identity, struggles against and transitions from colonialism to postcolonialism. Scarville's work is similarly concerned with questions of place, belonging, loss, and the diaspora, and in Harris's text finds a literary counterpart with strong aesthetic affinities. *Palace of the Peacock* describes the landscape in sumptuous and lively detail, infusing it with an agency that transforms it into a central character within the story. The polymorphic presence of Mariella is reimagined by Scarville in her photo series in both her human and land-based forms. The project began when Scarville, usually resident in Brooklyn, spent time in rural Maine, where the nights take on an intense, impenetrable darkness, so far from the polluting lights of any cityscapes. Scarville took up a practice of walking, camping, and performing repetitive, ritualistic gestures in the dark, taking photographs using long exposures and little more than the light from the moon and stars. The images included in *The Last Place They Thought Of* were made from 2016 to 2018 in numerous unidentified landscapes throughout the northeastern United States. In some images we see the artist's figure engaged in various rites; in others only the contours of sky, land, and water can be discerned. The artist is interested in cultivating a specific literacy both through the process of taking these photographs and in their presentation. For Scarville the experience was commensurate with learning a language of the landscape with practical and ideological applications—the tools necessary to negotiate and navigate the remote, rural, nocturnal terrains she temporarily inhabited. This included listening closely to the sounds and signs of life at night, distinguishing between the ambivalent activity of the landscape's harmless creatures and the threat of a potential predator.

The "placelessness" of the work's title speaks to the paradoxical character of the wilderness she documents, which, despite being captured momentarily, confounds the viewer's attempt to locate, identify, and fix it in time and place. This multiplicity and hybridized potential is akin to the continual process of subject formation, a process prompted and defined by spatial paradigms. Scarville acts to decenter the body and trouble binaries of nature/culture, human/nonhuman through a capacious engagement with her speculative landscapes. Placelessness is further suggestive of the ungeographic nature of blackness and black geographies, for example that of Guyana. A postcolonial nation located on the South American continent, Guyana belongs culturally, geopolitically, and socially to the Caribbean, a collection of islands in the Caribbean Sea. Defying its geographical confines, Guyana demonstrates the paradoxical potentiality of black geographies, their capacity for extending beyond physical borders and across bodies of water.

Stolen from indigenous peoples, lands in the United States and Caribbean have provided the setting for centuries of racial terror and forced labor. Scarville is invested in reimaging her relationship to landscapes scarred by history, particularly as a black, Guyanese-American woman. She seeks to repudiate images and notions of the black female as prey, vulnerable, and out of place, reinventing her own image as a shapeshifter, and her environment as one full of mystery, intrigue, and possibility. Making space for the unknowable, mystical, perhaps even magical qualities of the landscape at night mirrors the very expansiveness of the land, and seeks to recuperate the black female body in nature. Partly through the guise of the shapeshifter, she is at once a metaphor for the *placelessness* of the black female, the diasporic figure, and a vessel through which the individual navigates, commands, and is enveloped by space.

THE MIDDLE PASSAGE IS, OBVIOUSLY, NOT SIMPLY A THEORETICAL CONCEPT: IT IS A BODY OF WATER AND TIME ON A BODY OF WATER, WHICH IS INTERCONNECTED TO BLACK IMAGINATIVE WORK AND HOLDS DIFFERENT FORMS OF BLACK POLITICS AND BLACK TRAVELS AND EXILES.[11]

The cartographies of the water table, the transatlantic slave trade, and the Underground Railroad comingle in Torkwase Dyson's *Water Table* series, including her *Ecology of Everything* paintings. Dyson

[11] McKittrick, *Demon Grounds*, 18.

abstracts spatial configurations linked to these events, journeys, and geographies into geometric shapes that are then dispersed and layered onto the canvas in monochromatic fields of black, gray, and silver. Form, line, and color washes are interrupted by marks and indexical scores. The shape and texture of the paint and its movement across the canvas are suggestive of the ways bodies of water move and migrate across and around landscapes. Sharp geometric ciphers sit alongside and protrude into these watery residues, calling to mind manmade constructions, particularly those built to traverse the water. Perhaps what we see in Dyson's paintings is not just the outline of a ship, but the contours of its interior regions, such as its hold. The passengers—those deemed cargo—of slave ships bound for the Americas would have become painfully accustomed to that putrid architecture of confinement, crammed among other bodies bound on a six-week-long journey to a hostile destination.

Dyson is invested in how line and shape, in their delineation and division of space, can transform bodies. She locates spatial significance and aesthetic paradigms that become encoded into configurations for her paintings in the specific historical accounts of individuals—for example Harriet Jacobs and Henry "Box" Brown. Their narratives describe how bodies can and have, under extraordinary circumstances, negotiated natural and built environments by maneuvering, transgressing, and defying spatial paradigms, givens, etiquettes, and norms. Jacobs's garret, Brown's box, and the hold of the slave ship were painful enclosures that, for most, transformed their subject-position at the same time as their corporeal state—that is, if they survived. Those setting foot on the slave ship were stripped of their sovereignty, language, and culture and became something else, nonhuman, slave, property, black. Jacobs and Brown, upon entering their respective infrastructures, experienced a different becoming, of "freedom" (whatever that entailed or resembled for a black person in nineteenth-century America). Dyson's abstract paintings expansively contain the narratives of lives transformed by architecture, encoding their transgressions and repurposing of space for emancipatory means in expressive brushwork, densely pigmented fields, specters of color, and absences upon the canvas.

46

The four paintings from this series shown in *The Last Place They Thought Of* consider geographies of water and the connected, intersecting, historic spatial narratives—including chattel slavery, industrialization, and colonization—that have reconfigured their ecologies. An experienced diver, Dyson has observed the intense extraction throughout underwater environments along the routes of the Atlantic slave trade. These include coral reefs, kelp farms, and oil rigs in the Gulf of Mexico and along the shores of South Africa. The evidence of ecological degradation at the level of the water table becomes an integral element of the paintings and their composition. Imagine yourself as a diver standing on the ocean floor and looking up; the surface of the water would look like the surface of one of these paintings—populated by rays of light, blocks of shadow, and murky underwater clouds. Dyson views extraction through a relational and expansive lens, to encompass "humans from the continent, minerals from the underground reservoir, and liquid from the core of ancient waters." [12] Here, global warming and contemporary ecological changes are reckoned with as part of a continuum shared or instigated by the historical spatial narratives of colonization, chattel slavery, and the Industrial Revolution. The Anthropocene, for Dyson, is the amalgamation of these extractive practices and histories, and the past, present, and future of environmental justice lie in the "discourse between humanism and spatiality." [13]

CONCLUSION

The Last Place They Thought Of explored the intersections of geographical, ecological, ideological, and spatial paradigms, positing some possible critical frameworks for examining how they determine and reproduce uneven social relations. The paradoxical potential of black geographies and being *in the last place* is of great concern to the artists in the exhibition. Geographic space, the land, the wilderness hold a violent and dangerous meaning, particularly for black and native Americans, as the scene and setting of racial terrorism through genocide, bondage, and lynchings. At the same time, these spaces marked a path to freedom, by way of escapes along the Underground Railroad and into reservations and maroon communities that used the natural landscape for refuge and protection.

[12] Torkwase Dyson, artist statement on *The Water Table* series, unpublished, 2018.
[13] Ibid.

Taking up McKittrick's provocation that "black women's histori-cal-contextual locations bring to bear on our present geographic organization," *The Last Place They Thought Of* constituted a visual and spatial response to her questions, "How do geography and blackness work together to advance a different way of knowing and imaging the world?" and "Can these different knowledges and imagination perhaps call into question the limits of existing spatial paradigms and put forth more humanly workable geographies?"[14] Each artist employs an arsenal of visual strategies, from abstraction to staging, seriality, and performance, to deconstruct notions of nature, place, and the body. Advancing more complicated and nu-anced relationships between the body/self and the land/place, these artists reject the assumed binaries and hierarchies at their core.

Literary traditions, historical testimony, and a concern for the ground, the land, the earthly underpinnings of our geographic condition, reveal themselves in different, critical ways throughout the works in the exhibition. In Lorraine O'Grady's video *Landscape (Western Hemisphere)* the land is shown as a gendered and racialized body, projected onto the wall as an inversion of space and perspec-tive. In Torkwase Dyson's paintings, sites of spatial violence and terror are abstracted and re-encoded into geography as an act of memorialization and visualization of new aesthetic paradigms for writing and thinking space. Keisha Scarville's photographs capture the unknowable beauty and possibility of the land, reclaimed by the figure of a black woman. Jade Montserrat's monumental wall draw-ing demanded, took up, and transgressed the confines of its own space. Collapsing the body with language and the land, it entreated its audience to nurture and exchange future imaginaries.

To belong to the black diaspora is to be dispersed and out of place, but also located and claimed. This dichotomous relationship to place and belonging, and often to multiple places and cultures, is again a testament to the hybrid nature of living in the Western Hemisphere, as well as the continuing presence of the black Atlan-tic. Thinking through a black geographic lens, specifically through the multidisciplinary works in *The Last Place They Thought Of*, I hope, can encourage a multiplicity of ways of being, living, and belonging to space and place.

[14] McKittrick, *Demonic Grounds*, xxvi–ii.

DANIELLA ROSE KING

THE LAST PLACE
THEY THOUGHT OF

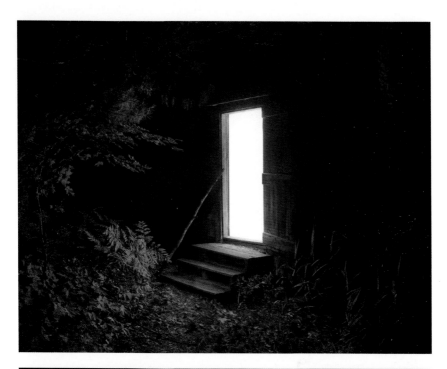

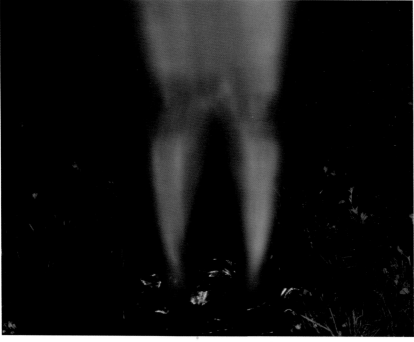

Keisha Scarville, *The Placelessness of Echoes (and kinship of shadows)*,
2016-2018. Archival inkjet prints, dimensions variable. Courtesy of the artist.

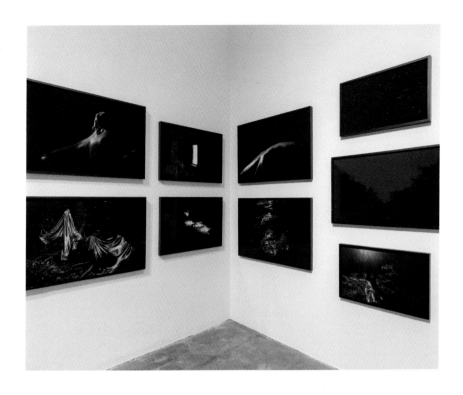

Above: Keisha Scarville, *The Placelessness of Echoes (and kinship of shadows)*, 2016-2018, installation view, *The Last Place They Thought Of*, 2018, Institute of Contemporary Art, University of Pennsylvania. **Right:** Keisha Scarville, *The Placelessness of Echoes (and kinship of shadows)*, 2016-2018. Archival inkjet prints, dimensions variable. Courtesy of the artist.

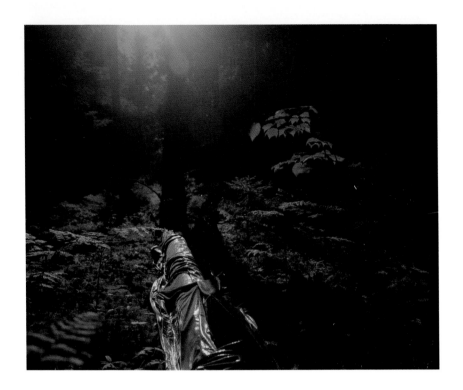

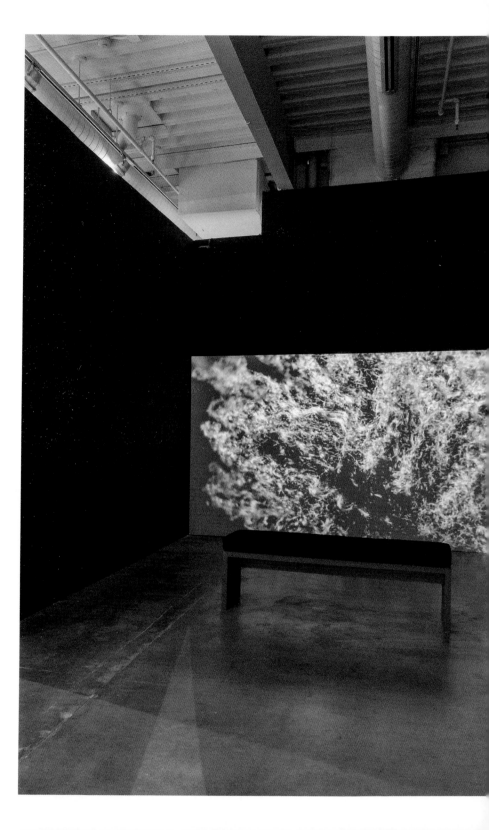

Lorraine O'Grady, *Landscape (Western Hemisphere)*, 2010-2011, installation view, *The Last Place They Thought Of*, 2018, Institute of Contemporary Art, University of Pennsylvania.

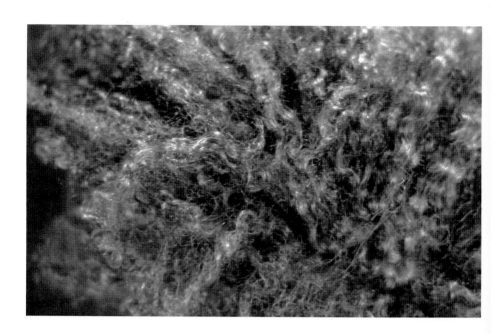

Lorraine O'Grady, *Landscape (Western Hemisphere)*, 2010-2011. Single
channel video for projection, 19 minutes. Courtesy of Alexander Gray
Associates, New York. © 2018 Lorraine O'Grady/Artists Rights Society
(ARS), New York.

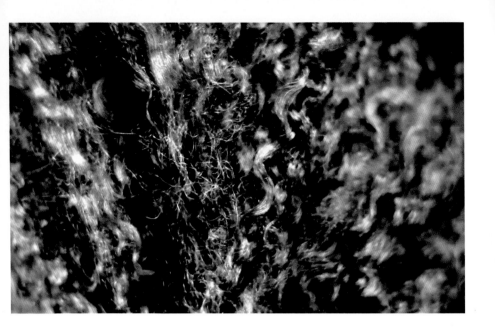

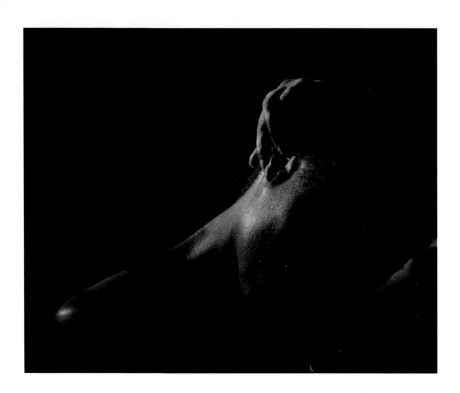

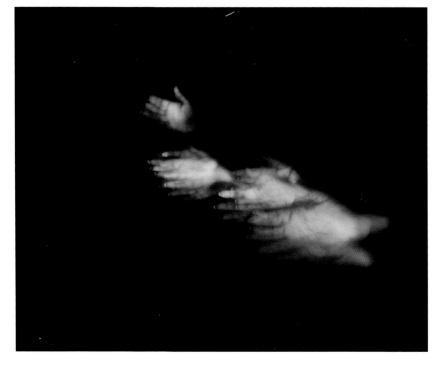

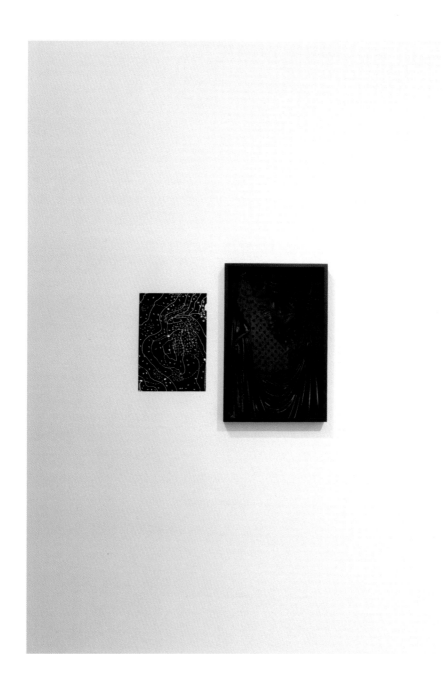

Above: Keisha Scarville, *The Placelessness of Echoes (and kinship of shadows)*, 2016-2018, installation view, *The Last Place They Thought Of,* 2018, Institute of Contemporary Art, University of Pennsylvania. **Right:** Keisha Scarville, *The Placelessness of Echoes (and kinship of shadows)*, 2016-2018. Archival inkjet prints, dimensions variable. Courtesy of the artist.

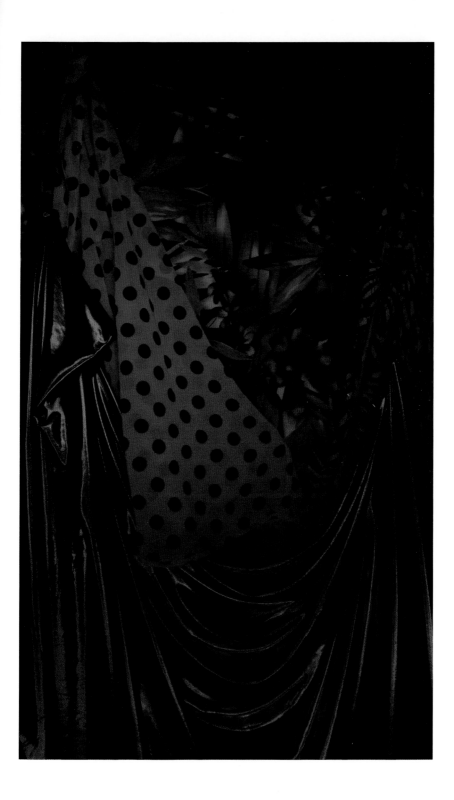

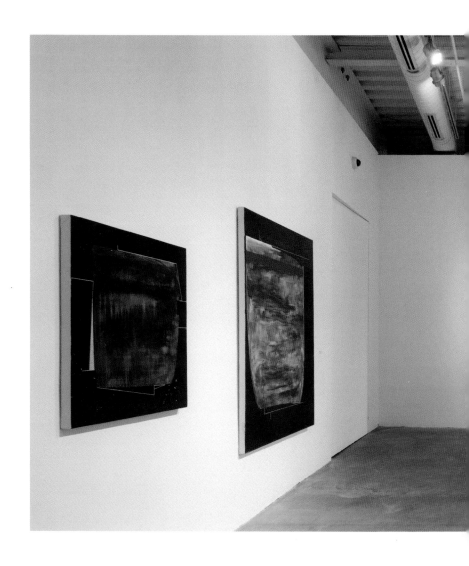

Torkwase Dyson: *Water Table 03*, 2017; *Ecology of Everything (Water Table 14)*, 2017; *Ecology of Everything (Water Table 12)*, 2017; *Water Table 02, 2017*, installation views, The Last Place They Thought Of, 2018, Institute of Contemporary Art, University of Pennsylvania.

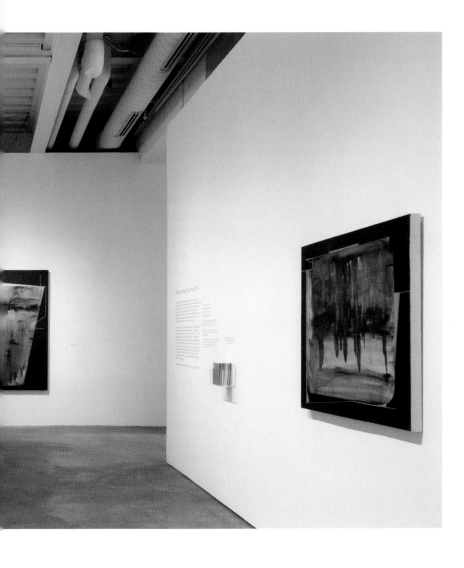

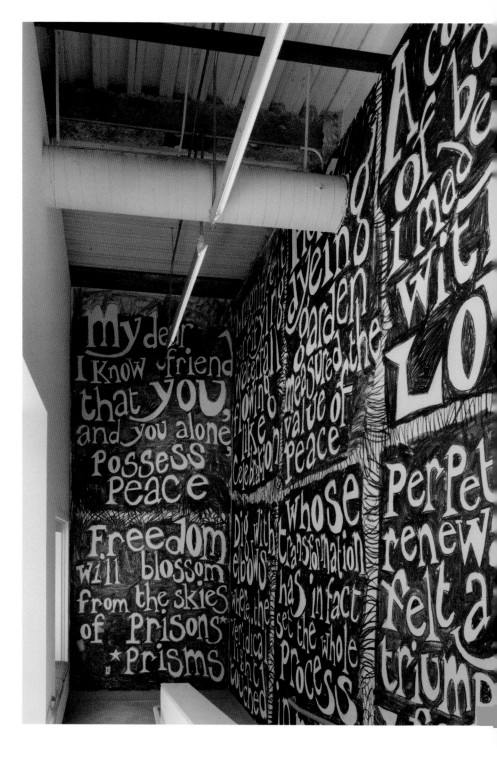

Jade Montserrat, *Untitled (The Wretched of the Earth, after Frantz Fanon)*, 2018, installation view, *The Last Place They Thought Of*, 2018, Institute of Contemporary Art, University of Pennsylvania.

Magnificent
terrifying
Waterfall
flowing
like
Celebration

Dig with
elbows
where the
Vertical

freedom
blossom
skies

alone

Keisha Scarville, *The Placelessness of Echoes (and kinship of shadows)*,
2016-2018. Archival inkjet prints, dimensions variable. Courtesy of the artist.

HOW BODILY GEOGRAPHY CAN BE;

THE MARGIN: BLACK FEMINISM AND GEOGRAPHY

KATHERINE MCKITTRICK

The history of the black diaspora converges with bodily schemas and racial codes. Most obviously, the geographies of transatlantic slavery were geographies of black dispossession and white supremacy, which assumed racial inferiority and justified enslavement. Geographies such as the slave ship, the slave auction block, slave coffles, and the plantation, are just some of the sites that spatialized domination under bondage. In particular, the ties between ownership and blackness rendered the black body a commodity, a site of embodied property, through ideological and economic exchanges. For black women, this legacy of captivity and ownership illustrates how bodily geography can be. Ownership of black women

during transatlantic slavery was a spatialized, gendered, often public, violence; the black female body was viewed as a naturally submissive, sexually available, public, reproductive technology. The owned and captive body was thus most profitable if it was considered to be a healthy, working, licentious, reproductive body. These characteristics were considered measurable and quantifiable, seeeable sites of wealth, sexuality, and punishment. Geographically, in the most crude sense, the body is territorialized—it is publicly and financially claimed, owned, and controlled by an outsider. Territorialization marks and names the scale of the body, turning ideas that justify bondage into corporeal evidence of racial difference.

Once the racial-sexual body is territorialized, it is marked as decipherable and knowable—as subordinate, inhuman, rape-able, deviant, procreative, placeless; or, to borrow from Dionne Brand, "the exposed, betrayed, valiant, and violated female self, the vulnerable and fearful, the woman waiting for the probable invasion" is made known through her bodily markings.[20] Challenging these knowable bodily markers—asserting, for example that blackness does

[20] Dionne Brand, "This Body for Itself," *Bread Out of Stone*, 101.

not warrant rape-ability—was/is punishable. Objectified black female sexualities represent the logical outcome of a spatial process that is is bound up in geographic discourses, such as territory, body/land possession, and public property. Geographic conquest and expansion is extended to the reproductive and sexually available body. Black women's own experiential and material geographies, consequently, indicate a very complex and difficult relationship with space, place, and dispossession.

Narratives such as *Incidents in the Life of a Slave Girl*, as alluded to, make inextricable the links between black feminine bodies, ownership, and geography. The unresolved spaces Harriet Jacobs/Linda Brent presents—on the Flint plantation, in the garret, with and among her family—are complexly linked to her unprotected, public, and unfree body as a black woman. Jacobs's/Brent's retreat to the garret is a geographic tactic designed to protect her body and her children's future bodies—from rape, violence, auctions, coffles, and labor that is analogous to "a slow murder."[21] What is made clear—by Jacobs's/Brent's "garreted" body and the legacy of racism and sexism—is that the

[21] Harriet Jacobs [Linda Brent], *Incidents in the Life of a Slave Girl*, 145.

stories of black women contain in them meaningful geographic tenets, but these are often reduced to the seeable flesh and unseeable geographic knowledges. However, Jacobs's/ Brent's retreat to the garret gets in between the seeable and the unseeable. In doing this, she creates a way to think about the histories of black women as they are wrapped up in a legacy of unprotected public bodies situated across the logic of traditional spatial arrangements—on slave ships and auction blocks, in garrets, under a white supremacist gaze, in white and nonwhite places. The very close ties among and between geography, race, gender, class, and sexuality become apparent through this history, and consequently develop new questions for our present social organization.

I am interested in thinking about the "close ties" between black women and geography because the connection reveals, as mentioned, how bodily geography can be. While the geographies of black women are certainly not always about flesh, or embodiment, the legacy of racism and sexism demonstrates how social systems organize seeable or public bodily differences. The creative work of poet and theorist

Marlene Nourbese Philip illustrates how black femininity as a seeable body-scale, comes to be understood through uneven geographies and resistances. Specifically, Philip's work illustrates the ways that racial-sexual difference is produced vis-à-vis an ongoing bodily history, which is both entrenched and alterable. Her important essay "Dis Place—The Space Between" reveals the kinds and types of geographies black women disclose and reinvent.[22] Asserting that the black female body and black female subjects are unquestionably geographic, and that a black sense of place is linked to what she calls "bodymemory," Philip uses real and poetic geographies to map a world that is necessarily infused with racial-sexual discourses. Philip uses the legacy of captivity and dispossession to write a historical present that cannot exist without black femininity and flexible geographies. She connects material geographies, such as the plantation, the nation, public streets, and legal borders, to a poetic geography of black femininity in order to show that the scale of the body, for black women, is both illustrative of public racialsexual disavowal and a location of politicization. That is, the body is understood

[22] I have also discussed the geographies of Marlene Nourbese Philip and "Dis Place" in "Who Do You Talk to, When a Body's In Trouble? Marlene Nourbese Philip's (Un)Silencing of Black Bodies in the Diaspora," 223-36.

by Philip as a historically produced terrain through which a different story is told—a geographic story produced from the last place they thought of, from the "place in between" the legs: the seemingly silenced and expendable black feminine body/parts and selves.

The linkages between black feminism and human geography are not forthrightly clear in social theory.[34] I have been trying, however, to present a frame through which the complex (paradoxical, bodily, poetic, "in the last place they thought of," mysterious, "in between") locations of black women might be analyzed While the work, ideas, and geographies I have presented thus far are to some degree limited (bodies, garrets, legs, memories, seeable public-unvisible women, in and across the black diaspora) and do not exemplify the breadth and particularities of black women's geographies in the diaspora, identifying some of the spatial themes black women draw attention to indicates how traditional geographies continually arrange uneven spatial practices. This unevenness which is predicated on the logic of visualization and seeable body-flesh, is underlined by continuities and ruptures: black femininities that continually call into question the possibilities and limitations of space and place. To put it another way, the spatial and bodily remnants of transatlantic slavery are un-

[34] There are few feminist or human geographers who extensively engage with black studies and particularly with black feminist studies (rather than antiracist, critical race, or "race" studies). In terms of interdisciplinary and conceptual connections across black feminism, black studies, and feminist geographies, exceptions include: Linda Peake and Alissa Trotz, *Gender, Ethnicity and Place: Women and Identities in Guyana*; Susan Ruddick, "Constructing Difference in Public Spaces: Race, Class and

resolved. Yet that which is unresolved is recast as a geographic struggle, which points to the tensions and gaps in existing landscapes. This can be seen on, through, and outside black women's body-spaces, throughout the innovative poetics of bodymemories and "in betweens," in the last place they thought of, and through the shape of mystery—the critical attic-space Harriet Jacobs/Linda Brent hides in. Furthermore, if the body clarifies the "close ties" between black women and geography, what deep space and poetics of landscape open up—as M. Nourbese Philip puts forward—is a way to express and politicize otherwise absent, or "garreted," histories and lives. Bodily geographies are not only unfinished and incomplete, they must have a place. Recognizing black women's knowledgeable positions as integral to physical, cartographic, and experiential geographies within and through dominant spatial models also creates an analytical space for black feminist geographies: black women's political, feminist, imaginary, and creative concerns that respatialize the geographic legacy of racism-sexism.

(cont'd) Gender as Interlocking Systems," 132-51; Peter Jackson, "Constructions of 'Whiteness' in the Geographical Imagination," 99-106. I also find the interdisciplinary work of geographer Ruth Wilson Gilmore useful: "Fatal Couplings of Power and Difference: Notes on Racism and Geography," 15-24; "Globalisation and U.S. Prison Growth," 171-88; "Public Enemies and Private Intellectuals," 69-78; "Terror Austerity Race Gender Excess Theatre," 23-37; "'You Have Dislodged a Boulder': Mothers and Prisoners in the Post-Keynesian California Landscape," 12-38.

VANTAPOWER

TREVA ELLISON

The Last Place They Thought Of offers us a set of approaches to blackness and black geographies that eschew singularity, universalism, and transparency as modes of embodiment and knowledge production while offering a different understanding of space and time that is grounded in the material histories of racial-sexual management and violent territorialization that continue to make the world as we know it. By visualizing, enacting, and ritualizing the reunion of body and flesh, the work in *The Last Place They Thought Of* invites us to witness how blackness confounds dominant social categories and spatial arrangements and calls us to think and theorize power from the purview of a black female subject positionality. The expressive force of this work, in my view, demands a formulation and conception of power that can think

from the shifting location(s) of blackness.

Vantapower names the power of blackness to upend, move below, and disperse dominant social categories and spatial arrangements. It is the power that comes *from* blackness. Blackness in this sense is not solely about the production of racial blackness and the racialization of space but instead blackness is closer to "the name that has been given to the social field and social life of an illicit alternative capacity to desire."[1] Articulating vantapower is a part of a blues calisthenics, a set of exercises in feeling and thinking from black geographies, a protocol and performance that considers how "the unknowable figures into the production of space."[2] Black geographies are always entangled with socio-spatial arrangements through which racism is reproduced, yet are distinct from these socio-spatial arrangements.[3] *The Last Place They Thought Of* explores how and where vantapower "shows up" in the material world: in the water tables of the Gulf South, in the construction of black womanhood, the forests of the Northeastern US in dialogue with Guyana, and the intellectual work of black studies.

Black geographies names the approach to the en-

[1] Fred Moten, "Blackness and nothingness (mysticism in the flesh)," *South Atlantic Quarterly* 112 (4), (2013): 737-780.
[2] Katherine McKittrick and Clyde Adrian Woods, eds. *Black geographies and the politics of place*, (Toronto: Between the Lines, 2007), 4.
[3] Katherine McKittrick, "On plantations, prisons, and a black sense of place," *Social & Cultural Geography* 12 (8), 947-963, 950.

twined production of space, place, race, and power that is most clearly articulated by late geographer and black studies scholar Clyde Woods and geographer and black studies scholar Katherine McKittrick. Black geographies is a method that has developed in attunement to the subterranean and alluvial movement of the black radical tradition, "the renunciation of actual being for historical being; the preservation of the ontological totality granted by a metaphysical system that had never allowed for property in either the physical, philosophical, temporal, legal, social, or psychic senses."[4] The relation of property is upheld by a socialized economic system of *racial capitalism*, that depends on the reproduction of racism via racial-sexual management. The property relation is also naturalized through a political and ethical system of *liberal humanism*, one that produces life, embodiment and personhood as property rights granted through the enclosure of land and the territorialization of everything. One of the primary contradictions of these interlocking onto-epistemologies of property is that they both depend on race as a framework for formalizing people and land variation into hierarchized

[4] Cedric J. Robinson, *Black Marxism: The making of the Black radical tradition* (Chapel Hill: University of North Carolina Press, 1983), 168.

classifications of human and geographic difference, the building blocks of the property relation. Race is one name for a highly evolved modality of formally instantiating property using the tools of law, ethics, reason, and formal aesthetics. The rights-bearing, citizen-subject of liberal humanism is a figure whose stability is subtended by the maintenance of a fragmented and dislocated *racial* otherness. Otherness is a form of existence that is in the *flesh*, the indeterminate form that precedes the construction of a recognized body and marks the point of passage between human life and non-human existence.[5] Flesh is the form of psycho-socio-spatial landlessness, of ungeographic-ness. The ungeographic is the last place they thought of; it is the spatial register of flesh and underscores that blackness is positioned in an indeterminate relationship to the production of space and time as knowable and calculable tools and systems of power.

Vantapower is the power that comes from the enactment of blackness, it comes from the enactment of "the social field and social life of an illicit alternative capacity to desire"[6] beyond the property relation. Vantapower is generated through the "blending of

[5] Hortense J. Spillers, "Interstices: A Small Drama of Words. 1984," in *Black, White, and in Color* (Chicago: University of Chicago Press, 2003): 152-175, 155, and Alexander G. Weheliye, *Habeas viscus: Racializing assemblages, biopolitics, and black feminist theories of the human.*, (Durham: Duke University Press, 2014).
[6] Moten, *Blackness and nothingness*, 737-780.
[7] Katherine McKittrick, *Demonic grounds: Black women and the cartographies of struggle*, (Minneapolis: University of Minnesota Press), 2006.

oppression, captivity, control, and agency,"[7] and comes from *the last place they thought of*, from the social field and social life of and in the flesh. Vantapower is essential to other forms of power like biopower, the power to administrate life congealed through the production and management of bodies and populations, and necropower, the power to subjugate life to death. This is because the power *to* produce subjects and subjugate life to death comes *from* the production of flesh, the indeterminate form in which the fact of biological existence offers zero political or ethical efficacy. Both biopower and necropower rely on vantapower as their unacknowledged geontological source.[9]

Articulating vantapower names *where* the power of subjection and subjectification comes from, even as that *where* refuses to be precisely or accurately located through the deterministic tools of productive reason.[10] Rather than trying to aestheticize or reclaim the black body and a black sense of place against its fragmentation, the works featured in *The Last Place They Thought Of* each meditate on the paradox of black geographies, being entangled with yet distinct from race, by staging reunions of body and flesh that recall and remember the violence of

[7] Katherine McKittrick, *Demonic grounds: Black women and the cartographies of struggle*, (Minneapolis: University of Minnesota Press), 2006.
[8] Alexander G. Weheliye, *Habeas viscus: Racializing assemblages, biopolitics, and black feminist theories of the human.* (Durham: Duke University Press, 2014).
[9] Elizabeth Povinelli, "Geontologies: The Concept and Its Territories" *eflux*, 81 (2017), accessed September 1, 2018, https://www.e-flux.com/journal/81/123372/geontologies-the-concept-and-its-territories/.

racial-sexual management, commodification, and territorialization while simultaneously enacting and asserting desires that disorganize common sense approaches to embodiment, place-making, and knowledge production, or the property relation.

The *vanta* in vantapower has two etymologies that reflect the paradoxes of blackness in relationship to space, place, and power. The *vanta* in vantapower is inspired first by the material Vantablack. Vantablack is the trademarked name for a material created by growing carbon nanotubes in densely-packed, vertical arrangement on a substrate, creating a vertically-aligned nanotube array or VANTA. Vantablack was created by UK tech company Surrey NanoSystems in 2014. It is the darkest known artificial substance, absorbing up to 99.965% of visible spectrum radiation. The primary application for Vantablack is disguising satellites and stealth aircraft. However, in February 2016 Vantablack became the subject of controversy in the art world when sculptor Anish Kapoor was given exclusive rights to Vantablack as an art material by Surrey NanoSystems. Kapoor remarked to Artforum: "The nanostructure of Vantablack is so small that it virtually has no materiality. It's thinner than a coat of paint and rests on the liminal

(cont'd) [10] For more on deterministic tools of productive reason see da Silva, Denise Ferreira. "1 (life) ÷ 0 (blackness) = ∞ − ∞ or ∞ / ∞: On Matter Beyond the Equation of Value." *eflux* 79 (2017), accessed September 1, 2018, https://www.e-flux.com/journal/79/94686/1-life-0-blackness-or-on-matter-beyond-the-equation-of-value/.

edge between an imagined thing and an actual one. It's a physical thing that you cannot see, giving it a transcendent or even transcendental dimension."[11] Painter Christian Furr was particularly furious, commenting to *The Daily Mail*: "All the best artists have had a thing for pure black: Turner, Manet, Goya. This black is like dynamite in the art world. We should be able to use it. It isn't right that it belongs to one man."[12] Both Kapoor and Furr's desires for the color black as an aesthetic or material in art underscore the image of black in western culture as a condition of existence that is for the use of others.[13] What gets abstracted in this kind of thinking is a black sense of place. What does it feel like to absorb all the light, to be between materiality and nothingness; what does it mean to be constructed as a bridge for transcendence?

Vantapower in this example expresses the power that comes from blackness as it is materialized and sourced via racial capitalism, the property relation, race, the commodity form, and through spatial acts of enclosure and territorialization. We can witness visual representations of vantapower in the abstract paintings of Torkwase Dyson. Dyson's *Water Table*, 2017 and *Ecology of Everything*, 2017 paintings sum-

[11] Claire Voon, "Anish Kapoor Gets Exclusive Rights to the World's Darkest Material," *Hyperallergic*, accessed September 1, 2018, https://hyperallergic.com/279243/anish-kapoor-gets-exclusive-rights-to-the-worlds-darkest-pigment/
[12] Ibid.
[13] Frantz Fanon, *Black Skin, White Masks*, (New York: Grove press, 2008) and Saidiya Hartman, *Scenes of subjection*, (New York: Oxford University Press, 1997).

mon the material geographies of water crises and how they are inflected by the racialization of space, using the color black to re-entwine the geographies of oil extraction with the legacies of anti-black racist spatial development. Dyson's art practice has consisted of deep sea diving near offshore drilling sites and traveling around America's southern states in a solar-powered, trailer-cum-studio, producing a method of abstract painting in conversation with black people and places in the Gulf Coast that she calls black compositional thought.[14] Dyson's work considers how the flesh/body distinction that underscores the production of the black body in western culture is critical to how we understand the architectures of power that circumscribe what is being called climate change and the Anthropocene. Being rendered a being for others, the condition of blackness is also the condition that circumscribes human-centered relations to land, water and other non-human entities. Dyson's *Water Table* series offers a different view of the world that insists on racism and blackness as enactments that upend the discourse of the Anthropocene.

Jade Montserrat's installation *Untitled (The Wretched of the Earth, after Frantz Fanon)*, 2018 similarly uses

[14] Torkwase Dyson, "Black Interiority: Notes on Architecture, Infrastructure, Environmental Justice, and Abstract Drawing," *Pelican Bomb* (2017), accessed September 1, 2018, http://pelicanbomb.com/art-review/2017/black-interiority-notes-on-architecture-infrastructure-environmental-justice-and-abstract-drawing, and Torkwase Dyson, and Danielle Purifoy, *In Conditions of Freshwater*, exhibition at Duke University Center for Documentary Studies, Durham, NC, March 2 –June 10, 2016.

black to draw together the production of black body/flesh, black knowledge production, and natural resource extraction. Montserrat used charcoal to draw a series of passages on the walls such as, "Her body, alone, concealed, an act of rebellion." Montserrat, who grew up in the rural north of England, locally sources the charcoal she uses in her durational performances, enunciating how the power that comes from blackness structures economic, political, and social relationships through commodity chains. Like Dyson, Montserrat's usage of black as a material is meant to underscore blackness as source, bringing to bear how blackness materializes through the commodity form and through the territorialization of the body via racial-sexual management.

After outlining the shapes of the letters and words of the phrases in charcoal, Montserrat underscores the phrases by using the charcoal to color in the blank space around the letters in each word of each phrase. In her inversion of the color scheme of printed text, Montserrat's iterative act of shading asks us to consider how the enactment of and negation of blackness are the processes around which the symbolic—the body of language, written word,

signs and signifiers, the law of the father, history, and the archive—is actively contoured. Montserrat produces the wall drawing nude, engaging with her own fleshliness to underscore how black female subject positionality is rendered in western culture as a field of social life that is not "bare" but shrouded in "layers of attenuated meanings, made in excess over time, assigned by a particular historical order."[15] Montserrat "strips" through these layers of meaning, staging the body as a form that indexes the violent commodification of black women's bodies through plantation capitalism and the degradative processes through which wood is burned to charcoal. Montserrat writes: "my body can reference other bodies that can be ironed out in history. I want to ask who those bodies are and reveal some of that, and not erase and flatten history."[16] Both Dyson's and Montserrat's art praxes hinge on enacting blackness as mode of sociality and relationality. Rather than merely instrumentalizing blackness as to affirm property, both Dyson's and Montserrat's usage of black as an art material imbricates sociality into the art object and site of display. Blackness in these works stays on the move, in the rituals, practices, and relationships that exceed the event of exhibition and the commodification of the art objects.

[15] Hortense J. Spillers, "Mama's baby, papa's maybe: An American grammar book," *diacritics* 17, no. 2 (1987): 65-81, 67, and Alexander G. Weheliye, *Habeas viscus: Racializing assemblages, biopolitics, and black feminist theories of the human.* (Durham: Duke University Press, 2014).
[16] Eno Mfon, "Artist spotlight: 'ironing out,' with Jade Montserrat." *gal-dem*, accessed September 1, 2018, http://nu.gal-dem.com/artist-spotlight-jade-montserrat/

Vantapower is generated in how the artists stage reuniting body and flesh, bringing the fleshly, often disregarded geographies of racial capitalism to bear on the body of legitimized socio-spatial knowledges.

The second etymology of the vanta in vantapower comes from the Latin meaning of the prefix *vanta*–which denotes a vanity, laziness, or lack. Black people often show up in dominant culture through these terms: lack, fragmentation, displacement, deficiency, and pathology. Vanta underscores the power generated from the iterative scripting of a black female subject position, one that conditions not just black subject formation but one that sets the terms for the reproduction of the relations of production, of racial capitalism and liberal humanism. To be placed in a black female subject position is to be rendered as flesh, to exist in an indeterminate relationship to categories of and ideals of being under liberal humanism like agency, embodiment, history, presence, self-determination, and rights. To be rendered in the flesh does not mean that one does not have a body, but that one's body materializes as the "half-shadow no-man's land"[17] between the facticity of biological existence and the efficacy of ethico-po-

[17] Gladys Bentley, "I am a Woman Again," *Ebony* 7 (1952): 92-98, 93.

litical entitlements and protections like personhood and self-consciousness. Black female subject positionality is an ongoing project that constitutes how we know the world. A black female subject position is the appositional *where* that the power to construct and reproduce the social categories that classify and instantiate human life both comes from and actively abstracts into near disappearance. Vanta as vain also indexes how blackness is on the move, resisting its enclosure via racial-sexual management. Vanta remembers how black people have often made queer use of dominant social and spatial structures, and how these queer uses often appear in the dominant cultural imaginary as a surplus of sexuality that is always threatening.

Vantapower is a call to see and recognize the disorienting power of black femme subject positionality. To intentionally stage the reunion of body and flesh as the exhibition does, is to beckon a coming to terms with what black literary theorist Hortense Spillers calls the "hieroglyphs of the flesh."[18] These are the often painful and violent cultural markings that have shaped the position and appearance of racial blackness in modern culture and highlight the limits of language and representation. This coming to

[18] Hortense J. Spillers, "Mama's baby, papa's maybe: An American grammar book," *diacritics* 17, no. 2 (1987): 65-81, 65.

terms is dangerous work because being made flesh and being placed in proximity to it is often accomplished through acts and cycles of violence. However, "living in the flesh"[19] also opens the possibilities for queer uses of the body that disrupt dominant socio-spatial paradigms and invite different kinds of desires that cannot be assimilated to or through the property relation.

Keisha Scarville's photographic series, *The Placelessness of Echoes (and kinship of shadows)*, 2016-2018 depicts a shapeshifter who becomes part of the nighttime landscapes of the northeastern US. *The Placelessness of Echoes (and kinship of shadows)* was developed in dialogue with Caribbean literature, particularly Wilson Harris's novel *Palace of the Peacock*, in which what is often bracketed and flattened as "landscape" is present as an active, living, and agential force. Scarville's photographs archive an experimental practice of surrendering the body to the fleshliness of landscape, to intentionally blur the boundaries between body and landscape, intervening on the human/nature divide that underscores the carbon imaginary, or "the idea that there is a natural and foundational distinction between life and nonlife; and that life, and human life in particu-

[19] Alexander G. Weheliye, *Habeas viscus: Racializing assemblages, biopolitics, and black feminist theories of the human.* (Durham: Duke University Press, 2014), 137.

lar, sets the ethical, social, and political conditions within which all activity can and should be assessed."[20] Dwelling on the indeterminate boundaries of the body in relationship to landscape, Scarville's praxis in *The Placelessness of Echoes (and kinship of shadows)* generates vantapower as it models a practice of thinking from a black female subject position, of reuniting body and flesh in a way that eschews the preservation of the distinction between human and non-human.

Lorraine O'Grady's 18 minutes video *Western Hemisphere*, 2010-2011 juxtaposes environmental noise from rural and urban landscapes with the waves and curls of O'Grady's hair. Through and between the tendrils of her hair, O'Grady presents an alternative spatial topography that summons the geographies of racial-sexual management and classificatory schemes that continue to be vital to the development of western civilization and the reproduction of the property relation. O'Grady's work generates vantapower by modeling how abstraction can be used as a black femme praxis that conveys the sense of socio-spatial indeterminacy around which knowable bodies and histories appear.

[20] Elizabeth Povinelli, "Native Life: Or, Being outside the carbon imaginary," lecture hosted by the Institute for Science, Innovation and Society, an Oxford Martin School Institute, March 7, 2014.

Vantapower vainly refers to itself; it has no subjects that are not also its objects. My own desire to conjure a register of power that thinks from a black female subject position is underwritten by the ways that bearing the hieroglyphs of the flesh is often violently displaced onto black people, particularly black women and black femmes, through the deployment of sex and gender as the staging grounds of racialization and racial fungibility.[21] Charting the trajectories of vantapower as it is generated from experimental reunions of body and flesh staged through black women's praxes of abstraction could constitute an approach to black feminism that is divested from reproducing the racist logic of biological sex and is more oriented towards producing scenes of black feminist fugitivity.[22] In that sense, *The Last Place They Thought Of* presents us with a range of approaches to the production of black feminist geographies, compressions of time and space that privilege hacking, experimentation, vulnerability, risk, and sociality over identification, knowability, and ontology. Each artist resists totalizing representations of the so called "black body", instead choosing to segment, re-constitute, conceal, work, or loop the body, staging it as a form through which to recall the legacies and architectures

[21] C. Riley Snorton, *Black on Both Sides: A Racial History of Trans Identity*, (Minneapolis: University of Minnesota Press, 2017), 17-54.
[22] Alexis Pauline Gumbs, *Spill: Scenes of Black Feminist Fugitivity*, (Durham: Duke University Press, 2016).

of power that have historically fragm-ented black peoples' bodies. *The Last Place They Thought Of* offers approaches to socio-spatial production that do not hinge on the negation of blackness and black female subject positionality but bring them to bear on traditional understandings of place, and power.

CONTRIBUTOR BIOGRAPHIES

Torkwase Dyson (born 1973, Chicago; lives New York) considers spatial relations an urgent question both historically and in the present day. Through abstract paintings, Dyson grapples with ways space is perceived and negotiated particularly by black and brown bodies. Explorations of how the body unifies, balances, and arranges itself to move through natural and built environments become both expressive and discursive structures within the work.

Selected solo presentations include the Graham Foundation, IL (2018); Bennington College, Bennington, VT (2018); Colby College, MN (2018); Davidson Contemporary, NY (2018), The Drawing Center, NY (2018); and group presentations at the Museum of Modern Art, NY (2018); the Whitney

Museum of American Art, NY (2018); Duke University, Center for Documentary Studies, NC (2016); and the Studio Museum in Harlem, NY (2015). Dyson is the recipient of a Joan Mitchell Foundation Painters & Sculptors award, Nancy Graves Grant for Visual Artists, Visiting Artist grant to the Nicholas School of the Environment at Duke University, the Culture Push Fellowship for Utopian Practices, Eyebeam Art and Technology Center Fellowship, and the FSP/Jerome Fellowship. Dyson's work has also been supported by the Eyebeam Art and Technology Center, The Laundromat Project, the Green Festival of New York, Obsidian Arts and Public funds of the City of Minneapolis, Mural Arts Program of Philadelphia, The Kitchen, and Dorchester Projects in Chicago. Dyson is a critic at the Yale School of Art.

Treva Ellison, Assistant Professor of Geography and Women, Gender, and Sexuality Studies at Dartmouth College, is an interdisciplinary scholar whose research is at the intersections of trans and queer historiography, carceral geographies, and social movements in the United States. Ellison's writing appears in places such as Transgender Studies Quarterly, Feminist Wire, and Scholar and Feminist Online. Ellison is currently working on their manuscript project, *Towards a Politics of Perfect Disorder*, which historicizes the articulation of trans and queer criminality in Los Angeles in relation to the racialization of space.

Towards a Politics also traces grassroots activism around anti-trans and queer policing initiatives, including how the institutionalization of such efforts shapes the contemporary landscape of trans and queer politics in Los Angeles. Ellison earned their doctorate in American Studies and Ethnicity from the University of Southern California in 2015.

Daniella Rose King, the 2017-2020 Whitney-Lauder Curatorial Fellow at the Institute of Contemporary Art, University of Pennsylvania, is a London-born writer, curator, and producer concerned with the social history of art, particularly when it brings to light forgotten, oppressed, or difficult histories, moments of struggle, and spaces of resistance. Prior to joining the Institute of Contemporary Art she was based in New York where she worked with Naeem Mohaiemen on the documenta 14 commissions, *Two Meetings and a Funeral* and *Tripoli Cancelled*, and Simone Leigh as curatorial researcher for her New Museum exhibition and residency "The Waiting Room," and Tate Modern project "Psychic Friends Network." In 2017 she curated "On Visibility and Camouflage: Black Women Artists for BLM" at We Buy Gold in Bedford-Stuyvesant, Brooklyn. King was the 2015-2016 Whitney Independent Study Program Helena Rubinstein Curatorial Fellow, where she curated "On Limits: Estrangement in the Everyday" at The Kitchen, NY in 2016.

She has contributed to exhibition catalogs, magazines, journals and online platforms. Her writing has most recently appeared in The Whitney Biennial 2019 catalog, *Black Refractions: Selections from the Studio Museum in Harlem Collection*, the 10th Berlin Biennial catalogue, the Studio Museum in

Harlem 2017 Artist in Residence Brochure; as well as Ocula Magazine, Frieze, Art-Agenda, Art Monthly, Ibraaz, Harpers Bazaar Art, New African Magazine, Contemporary And, Portal 9 Journal, and Nafas Art Magazine.

King has held institutional positions as Assistant Curator at Nottingham Contemporary; Program Curator at MASS Alexandria, Egypt; Exhibitions and Events Manager at Iniva, London; visiting curator at Cornerhouse (now HOME) in Manchester; and deputy curator of the Cyprus Pavilion at the 56th Venice Biennale, and is co-founder of the curatorial collective, DAM Projects.

Katherine McKittrick is Associate Professor of Gender Studies at Queen's University in Kingston, Ontario, Canada. McKittrick authored *Demonic Grounds* and edited and contributed to *Sylvia Wynter: On Being Human as Praxis*. Her research is interdisciplinary and attends to the links between theories of liberation, black studies, and cultural production. McKittrick's monograph, *Dear Science and Other Stories* (Duke University Press, forthcoming), is an exploration of black methodologies. She is currently working on two projects: the first, unnamed, attends to questions of extraction in relation to black studies, the physical geographies of the black Atlantic, and black cultural production; the second, *Pastel Blue*, studies color, color theory, image-making, and black creative text. Her research program also attends to the writings of Sylvia Wynter. She co-edits the Duke University Press book series *Errantries*.

Jade Montserrat (born 1981 London; lives Scarborough, UK) works at the intersections of art and activism, progressing through performance and live art, works on paper and interdisciplinary projects. Montserrat interrogates these mediums with the aim to expose gaps in our visual and linguistic habits. She studied at the Courtauld Institute of Art in London and the Norwich School of Art and Design, and is the Stuart Hall Foundation practice-based PhD fellow at The Institute for Black Atlantic Research at The University of Central Lancashire, UK, her research project is titled "Race and Representation in Northern Britain in the context of the Black Atlantic: A Creative Practice Project".

Her work has been shown in solo and group presentations at SPACE (2017); Alison Jacques Gallery (2017); Galerie Norbert Arns, Cologne (2017); Spike Island, Bristol (2017); Arnolfini Centre for Contemporary Art, Bristol (2017); The Showroom, London (2016); Cooper Gallery, University of Dundee, Scotland (2016); Institute of International Visual Art, London (2014); and has been included in programs and talks at Princeton University, NJ (2016); The Kitchen, NY (2016); the Royal College of Art, London (2017), Tate Modern, London (2017), and in 2017 was a recipient of the Jerwood Drawing Prize.

99

Lorraine O'Grady's (born 1934, Boston; lives New York) oeuvre as an artist draws inspiration from the ordinary to produce works that reveal the complexities and conflicts inherent to the human experience. Since the early 1980s, O'Grady has challenged racial and sexist ideologies in performance and photo installations that combine opposition to philosophies of division and exclusion as well as humanist studies of women throughout history.

O'Grady's work has been recently exhibited at Crystal Bridges, AR (2018); Tate Modern, London (2017) and the Brooklyn Museum, NY (2017); Centro Andaluz de Arte Contemporáneo, Sevilla, Spain (2016); Carpenter Center for the Visual Arts, Harvard University, Cambridge, MA (2015); the Studio Museum in Harlem, NY (2015, 2013, and 2012); MoMA PS1, NY (2014); Walker Art Center, Minneapolis, MN (2014); la Bienal Internacional de Arte Contemporáneo, Cartagena, Colombia (2014); the Museum of Contemporary Art, Chicago (2012); the Whitney Biennial, NY (2012 and 2010); Arab Museum of Modern Art, Doha, Qatar (2012); La Triennale Paris, France (2012); and ICA, Boston, MA (2012).

Her work is represented in the collections of MoMA, NY; Art Institute of Chicago, IL; Los Angeles County

Museum of Art, CA; Brooklyn Museum, NY; Rose Art Museum Museum, Waltham, MA; Walter Art Center, Minneapolis, MN; and Fogg Art Museum at Harvard, Cambridge, MA. O'Grady has been a resident artist at Artpace San Antonio, TX, and has received numerous other awards, including the CAA Distinguished Feminist Award, a Lifetime Achievement Award from Howard University, the Art Matters grant, Anonymous Was A Woman, the United States Artists Rockefeller Fellowship and, most recently, is a Creative Capital Awardee in Visual Art.

Keisha Scarville (born 1975, Brooklyn, NY; lives Brooklyn) weaves together themes dealing with transformation, place, and the unknown. She studied at the Rochester Institute of Technology (RIT) and Parsons/The New School. Her work has shown at the Studio Museum of Harlem, Rush Arts Gallery, BRIC Arts Media House, Lesley Heller Gallery, Contact Gallery in Toronto, Aljira Center for Contemporary Art, Center for Photography at Woodstock, the Caribbean Cultural Center African Diaspora Institute, Museum of Contemporary Diasporan Arts, and The Brooklyn Museum of Art. Scarville has taken part in residencies at Vermont Studio Center, Skowhegan, LMCC, BRIC Workspace Residency Program, and Light Work. She has presented lectures at the International Center of Photography (ICP) and at New York University (NYU), both NY. Reviews of her work have appeared in the New York Times, Vice, Transition, Nueva Luz, Small Axe, The Village Voice, and Hyperallergic. Her work is in the collection of the Smithsonian Institute in Washington, DC. Currently, Scarville is a faculty member at the International Center of Photography and Parsons School of Design, The New School, New York.

CHECKLIST

Torkwase Dyson
Water Table 02
2017
Acrylic on canvas
Courtesy of the artist and
Davidson Contemporary,
New York

Water Table 03
2017
Acrylic on canvas
Courtesy of the artist and
Davidson Contemporary,
New York

*Ecology of Everything
(Water Table 12)*
2017
Acrylic on canvas
Courtesy of the artist and
Davidson Contemporary,
New York

*Ecology of Everything
(Water Table 14),*
2017
Acrylic on canvas
Courtesy of the artist and
Davidson Contemporary,
New York

Lorraine O'Grady
Landscape (Western Hemisphere)
2010-2011
Single-channel video, black-
and-white, sound, 18 minutes
Courtesy of the artist and
Alexander Gray Associates,
New York

Jade Montserrat
*Untitled (The Wretched of the
Earth, after Frantz Fanon)*
2018
Site specific charcoal wall-
drawing, dimensions variable
Courtesy of the artist

Keisha Scarville
*The Placelessness of Echoes
(and kinship of shadows)*
2016-2018
Archival inkjet prints,
dimensions variable
Courtesy of the artist

STAFF LIST

(all staff April 27-August 12, 2018)

Amy Sadao
Daniel W. Dietrich, II Director

Kate Abercrombie
Registrar

Hilary Alger
Interim Director of Development

Liz Barr
Programs Coordinator

James Britt
Director of Public Engagement

Jeffrey Bussmann
Associate Director of
Development for Individual Gifts

Robert Chaney
Marc J. Leder Director of Curatorial
Affairs

Gina DeCagna
Van Doren Engagement Fellow

Lauren Downing
Curatorial Assistant

Anthony Elms
Daniel and Brett Sundheim Chief
Curator

This book is published on the occasion of the exhibition *The Last Place They Thought Of*, curated by Daniella Rose King and organized and presented by the Institute of Contemporary Art, University of Pennsylvania, April 27– August 12, 2018.

Excerpts from "Introduction: Geographic Stories" and "The Last Place They Thought Of: Black Women's Geographies," from Katherine McKittrick, *Demonic Grounds: Black Women and the Cartographies of Struggle* (Minneapolis: University of Minnesota Press, 2006) pp. xii-xxi, 44-53, are reprinted here with the permission of the author and the publisher. Copyright 2006 by the Regents of the University of Minnesota.

Editor: Daniella Rose King

Design: Paige Hanserd
Photography: Constance Mensh
Typefaces: Canela, Oroban, Maison Neue, GT America, Druk

Printed by Shapco

First Edition
Edition of 750

ISBN: 978-0-88454-142-4

Institute of Contemporary Art
University of Pennsylvania
118 S. 36th Street
Philadelphia, PA 19104-3289
www.icaphila.org

Library of Congress
Cataloging-in-Publication Data
CIP data can be obtained at the Library of Congress

Every reasonable attempt has been made to locate the owners of copyrights in the book and to ensure the credit information supplied is accurately listed. We welcome any uncredited creators to come forward so that we may acknowledge them, and correct any errors or omissions in future editions.

Support for this exhibition and for ICA's Whitney-Lauder Curatorial Fellow Program has been provided by the Leonard & Judy Lauder Fund.

ICA is always Free. For All.
Free admission is courtesy of Amanda and Glenn Fuhrman.

ICA acknowledges the generous sponsorship of Barbara B. & Theodore R. Aronson for exhibition publications. Programming at ICA has been made possible in part by the Emily and Jerry Spiegel Fund to Support Contemporary Culture and Visual Arts and the Lise Spiegel Wilks and Jeffrey Wilks Family Foundation, and by Hilarie L. & Mitchell Morgan. Marketing is supported by Pamela Toub Berkman & David J. Berkman and by Lisa A.& Steven A. Tananbaum. Public Engagement is supported by the Bernstein Public Engagement Fund. Additional funding has been provided by The Horace W. Goldsmith Foundation, the Overseers Board for the Institute of Contemporary Art, friends and members of ICA, and the University of Pennsylvania. General operating support is provided, in part, by the Philadelphia Cultural Fund. ICA receives state arts funding support through a grant from the Pennsylvania Council on the Arts, a state agency funded by the Commonwealth of Pennsylvania and the National Endowment for the Arts, a federal agency.